Cyanotypes on Fabric

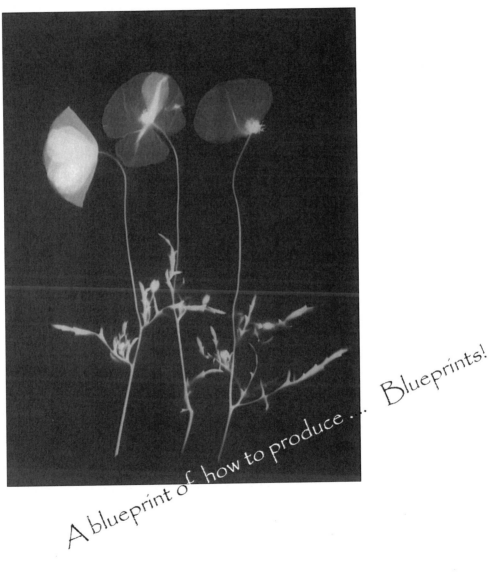

A blueprint of how to produce Blueprints!

Ruth Brown

SC Publications

Published in Great Britain by

SC Publications
Stone Creek House, Sunk Island
East Yorkshire. HU12 0AP
Tel: 01964 630630
E-mail: info@sc-publications.co.uk

First published in 2006
Revised edition 2016

A copy of this publication has been registered
with the British Library.

ISBN 978-0-9554647-5-1

Printed by:
CreateSpace.com

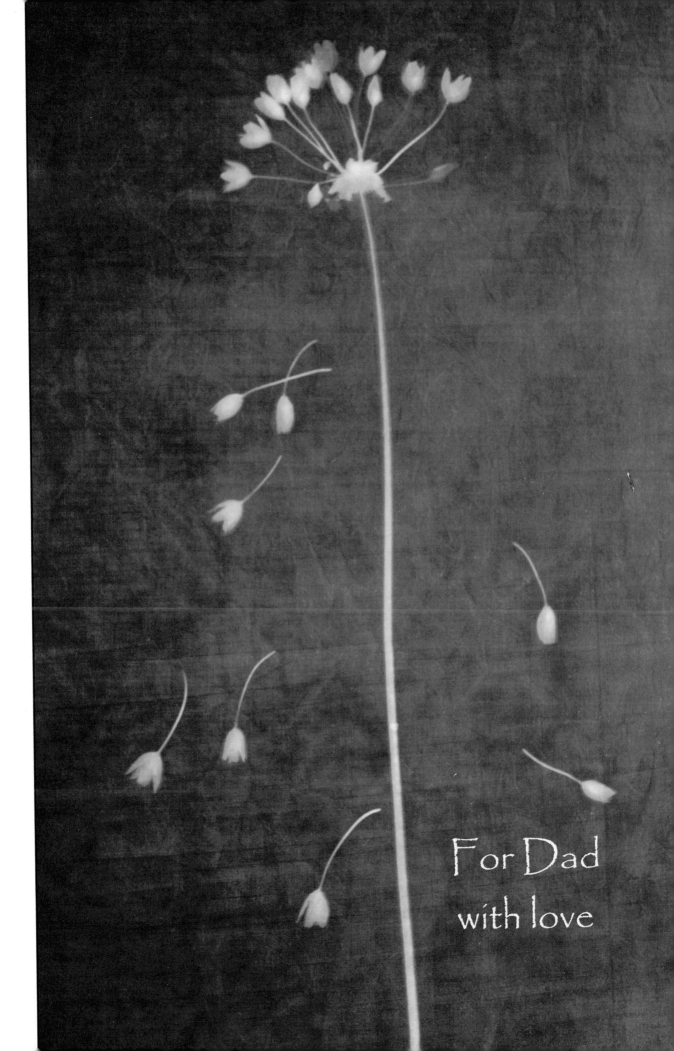

For Dad
with love

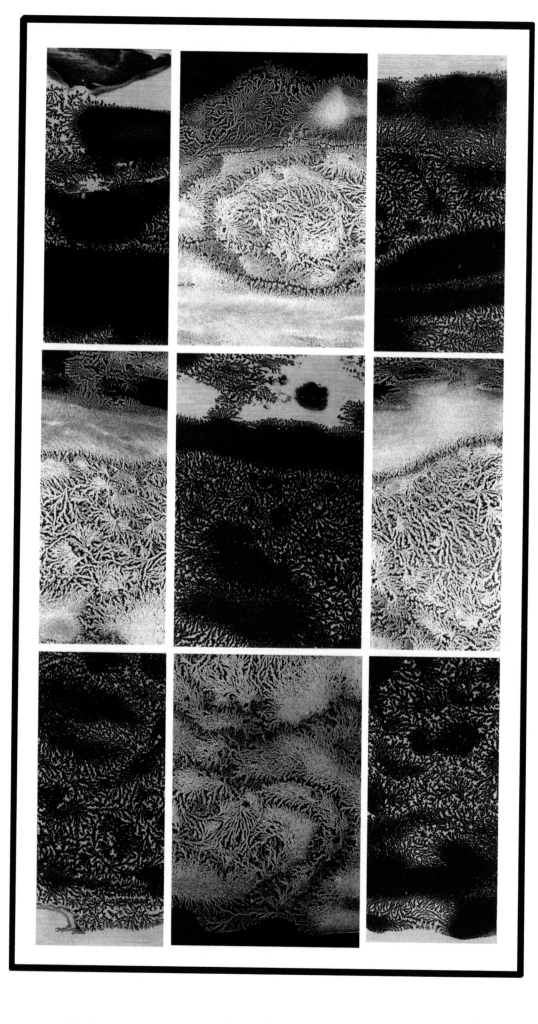

Acknowledgements ...

Gosh, where do I start? So many people have encouraged and supported me so my thanks go to all of them and to the following, in no specific order:

Barbara Hewitt for writing the book, Blueprints on Fabric, that started me off with cyanotyping. Also to Caroline Munns of Rainbow Silks for selling it to me and, unknowingly, starting this whole project.

Liz and Tony Booth for feeding us at regular intervals, for supplying comfort and encouragement and for being excellent guineapigs! Also to Tony for letting me use his photographs and to Liz for proof reading duties.

Bob Hewson for supplying the health and safety information.

Brian Liddy and his staff from the National Media Museum in Bradford for letting me see the priceless album of Anna Atkins's original cyanotypes and for digging out other useful references.

Vicky Taylor, also known as Mum, for her love.

Hazel Hewson, Jane White and Anne Branton for supplying flowers and foliage from their lovely gardens.

Mitch Phillips who gave words of encouragement and who introduced me to other artists working on fabric with the cyanotype process.

Mike Ware for answering my questions with patience and charm.

Sue Lowday for lending me her glass negatives.

Craig Burton for letting me use his original photographs.

Finally, and most importantly, my husband Iain who supports and loves me through thick and thin!

Opposite: Cyanotype created from alternating positives and negatives. See page 59 for details on how this was done.

Contents ...

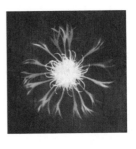

Introduction ...

There is something very satisfying about blue and white - think of delft pottery, indigo dyed textiles, Wedgwood ceramics, white clouds in a summer sky, willow pattern plates For me Prussian blue, the colour of cyanotypes, is calm, cool, classic and liberating after working with my more vibrant palette for so long. Using just blue and white, I don't have to consider the interaction of colours so I look more closely than usual at the edges of shapes, at the often unexpected detail in translucent things like bluebells or dragonfly wings. Intricate outlines are seen that can otherwise be missed, like the delicate hairs on the stem of a poppy or the exquisite patterns along the edge of a piece of rusted metal.

The beauty of cyanotyping is that you can capture and preserve these observations on paper or fabric without a darkroom, an enlarger or precise developing procedures. You don't need to be able to draw or mix colours. You don't even need anything more than fairly basic computer skills if you want to produce your own negatives.

As a child I always thought that photography was a form of magic - someone pointed a small box at you and a few days later there was a memory of the event. Later, when digital photography came along, I took to it readily as, having spent 20 years in IT, I had the equipment and knowledge to 'develop' my own photos.

Then I found a book called Blueprints on Fabric by Barbara Hewitt - here was a simple process for producing subtle, beautiful photographs on fabrics - photos I could frame, photos I could paint, photos I could sew, photos I could wear! I could make small panels for quilts from the wild flowers outside my house or large pieces of fabric for making jackets from photographed textures combined with seed pods or grasses......The route between that day and this book has been such fun - thank you Barbara. Fabric, photography and IT - what more could I ask?

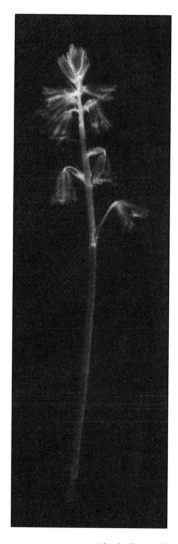

Bluebell on silk
from digital negative

* * * * * * *

I'd like to encourage you to do two things: break the rules and trust your own judgement. I think that nothing should be written in stone - experiment, play, have fun! Once you've understood the basic process then break the rules (except the health and safety ones!). Stepping outside your comfort zone can be a scary but exhilarating experience.

Try combining different disciplines. A whole series of 'what if' thoughts led to experiments combining cyanotypes with other textile techniques. Can I underdye? Yes. Can I paint over a cyanotype? Yes. Can I use other resists? Oh yes! Add in computer enhanced and altered images and there is enough food for thought to keep me going for a long time.

As for the 'trust your own judgement' part, by this I mean that if you like a particular end result then that's the only thing that matters; the only criterion I use is whether an image pleases me visually. I don't care if what I produce is a 'good' photograph - I like what many photographers deem to be faults. So produce what YOU like.

The purpose of this book is to show you how the cyanotype processes work and to encourage you to try new things and experiment. You'll certainly end up with something unique in a mass produced world. It has been my delight to take an old technique and try and give it some new twists, sometimes literally! I hope you enjoy it.

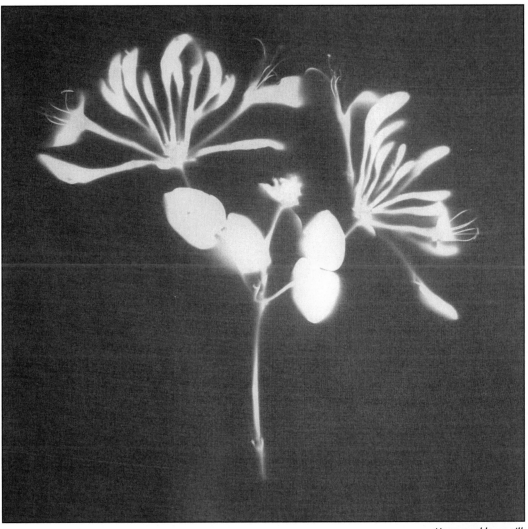

Honeysuckle on silk
photogram

Artists throughout the ages have eulogised about the qualities of light and have sought to capture those qualities in their work. The thought appeals to me that the cyanotype process depends on the part of light that we cannot see, that is ultraviolet light, to produce an image

How the cyanotype process works ...

An Overview

On the day I started to write this section of the book I inadvertently created a photogram on myself. I stayed in the sun too long with strappy sandals on my feet. When I took them off the areas that had been covered up by the straps stayed the original colour but the areas exposed to the sun changed colour. This is the basis for creating cyanotypes: you block light from the areas you want to remain white and the areas where the light strikes the treated fabric will turn blue.

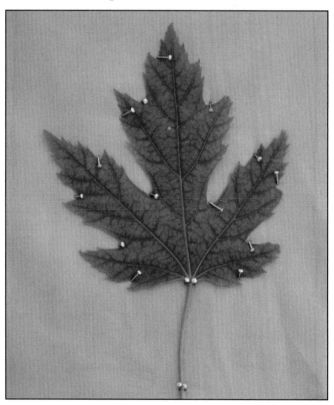

In this picture you can see the pins holding the leaf in place for the exposure

Making cyanotypes is a simple, 4 stage process that requires no darkroom, no enlarger and no precise developing procedures. That's my kind of process!

Firstly you make a yellow/green light sensitive solution from two chemicals dissolved in water (the recipe is in the next chapter). This is applied to a surface, such as fabric or paper, and is left to dry somewhere dark. You now have the equivalent of a piece of photographic paper that is ready to be exposed.

The next step is to place objects, flowers, foliage or a photographic negative on top of the treated fabric. These design elements stop the light from reaching parts of the fabric and will form an image on your light sensitive fabric during the next stage.

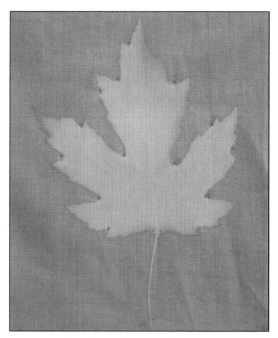

This shows the exposed cyanotype with the leaf removed

Thirdly the fabric with the design elements on top is exposed to the sun or another form of UV (ultraviolet) light, such as a sunbed. The exposed areas turn a slate blue/grey and the unexposed, covered up areas stay the original yellow/green.

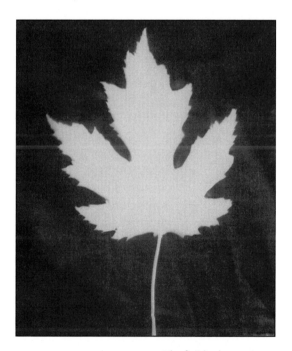

The finished cyanotype

Once the exposure is complete the print is washed in plain water. The light sensitive solution that has been covered up simply washes away in the rinsing process leaving a white image. The exposed background turns a gorgeous Prussian blue, which is permanent.

To sum up, you treat the fabric, put something on top, expose it and wash it in water. Each of these steps is explained in detail in the following chapters. There are also sections on making digital negatives, colouring cyanotypes, combining this technique with other textile methods and on taking care of your finished work.

Although cyanotypes can be made on a wide variety of surfaces such as paper, wood, card, leather and so on, this book is about cyanotypes on fabric - a simple but endlessly fascinating process. You can, of course, buy ready prepared fabric and paper, indeed the first reference I've found to commercial cyanotype fabric (Silkdown) is from 1907[1], but preparing your own is easy, saves money and allows you to use almost any suitable natural fibre fabric you like.

1 *The Photo Miniature – a Magazine of Photographic Information, edited by John A Tennant. Volume VII, September 1907, Number 82, page 433.*

Preparing the fabric ...

This is a very simple process which has been used for over 150 years but, to ensure that you and the environment are kept safe, please handle the chemicals carefully and read the health and safety advice in Appendix I before you begin. Use sensible precautions but don't become so paranoid that you can't enjoy a wonderful process.

Choosing your fabric

Cyanotypes work on a variety of surfaces but, being a textile artist, I use natural fibre fabrics, usually silk or cotton but also linen, hemp, rayon and silk/viscose velvet sometimes. The light sensitive solution won't penetrate any of the synthetic fibres I've tried; it looks fine when you put it on the fabric and when it's been exposed but it disappears when it's washed. One Internet site suggested spraying starch on synthetic fibres to anchor the cyanotype solution on to the fabric. Unfortunately the starch washed away during the processing, taking the cyanotype image with it. I haven't by any means tried every fibre available so if you are in doubt, do a test piece and see what happens.

Whatever you choose must be clean and free of any surface treatments, including fabric conditioners. You can buy from a supplier who specifies that their fabrics are 'prepared for dyeing' (PFD), which means they should be free of any surface treatments that could stop the cyanotype solution adhering to the fibres. Clothing such as t-shirts may well have a surface dressing on them and should be washed before use.

If you do wash fabric or clothing use one of the products recommended in the chapter on 'Taking care of your Cyanotypes' so that you don't accidentally leave any residue in your fabric that might damage your print. Powdered detergents particularly should be avoided as undissolved particles may 'spot' your print.

One further point on this, some silks still contain the natural gum sericin, that the silk worms use to stick the cocoon together. This will reduce the amount of cyanotype solution being absorbed into the silk. The sericin can be removed by scouring with soda ash (see the

To remove the sericin from silk use the recipe from Yoshiko Wada's book 'Memory on Cloth' - p194. Weigh the fabric you want to scour then take 10% of that weight in soda ash(washing soda) and dissolve in 40 times that weight in water (1ml = 1g). Simmer the silk in the solution for 30 minutes. Allow to cool then rinse VERY well, adding a splash of vinegar to the final rinse if you live in a hard water area. Alkaline conditions can damage your cyanotype badly so the final rinse wants to be in neutral/slightly acidic water.

Example:
100g fabric needs 10g soda ash in 4000g water= 4 litres

side panel) but it's much easier to buy suitable fabric in the first place.

If you have a particular project in mind then it's worth giving a bit of thought to the surface of the fabric you're going to use. Different surfaces will give different results - a rough or loose weave will break up the detail of the images whereas a fine, smooth weave will allow a very sharp, detailed image.

White spun rayon

White silk habotai

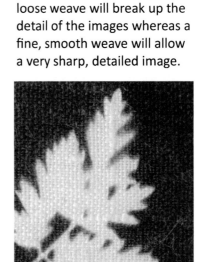

White loose weave linen

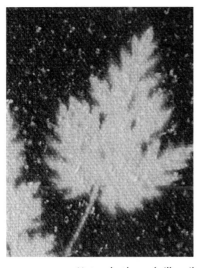

Natural coloured silk noil

Textured weave viscose

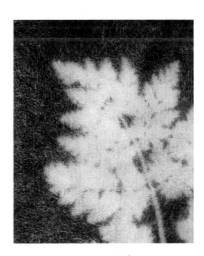

White silk/viscose velvet

Here are some examples of a simple photogram on different fabrics.

The velvet is particularly intriguing as the light often doesn't penetrate through the pile to the backing so the image is on the pile only!

The main advantage of preparing the fabric yourself is that you have the choice of fibre and weave from a delicate, dreamy silk chiffon, or a crisp, cool linen through a smooth, tightly woven cotton to a rich, sumptuous velvet. You aren't limited to what is commercially prepared, you can pick the most suitable fabric for your project. The only natural fibre fabric that I've had trouble with is wool. I can only assume that the lanoline in the wool stops the solution penetrating.

What do you need to get started?

Most of the items you need for this process are cheap and easily found.

➤ A set of scales with 1 gram divisions is quite adequate for this process so some kitchen scales will do, postal scales can be found at stationery suppliers or, alternatively, you can go to a laboratory /photographic supplies company who will certainly have something suitable.

➤ A plastic or pyrex measuring jug for mixing the solutions

➤ Plastic or wooden spoons for getting dry chemicals out of their containers and for stirring to dissolve them.

➤ Storage bottles plus labels and a waterproof pen.

➤ The relevant chemicals - see the next section.

➤ Your choice of clean, dry natural fibre fabric.

➤ Dust mask, gloves, protective clothing

➤ A small funnel can be useful for transferring the dissolved chemicals into storage bottles.

➤ A large, soft brush such as a hake or household paint brush, or a small sponge.

➤ Frame and pins (optional)

➤ Plastic clothes line and pegs (optional)

It's worth stressing that all the utensils you use for this process should be marked and should not be used afterwards for food preparation.

Firstly you need to prepare your light sensitive solution.

The chemicals

The two chemicals used are:

➤ Ferric ammonium citrate (sometimes called ammonium ferric citrate), which is a green powder. It absorbs moisture from the air so keep it in an air tight container. It is also a very light powder so it's best not to have a window open while you are measuring this out as it can fly everywhere.

And

➤ Potassium ferricyanide, which is in the form of bright red crystals. Read the section in the Health and Safety Guide on this chemical - it is classed as an irritant so you need to take suitable precautions but it is nothing like as nasty as the name might suggest. There is another chemical with a VERY similar name, potassium ferr(o) cyanide rather than potassium ferr(i)cyanide - not the same thing.

If you really get into this process it could be worth investigating the new cyanotype process by Mike Ware described in his book, 'Cyanotype', which he's generously made available as a free download under the title Cyanomicon - see bibliography

I haven't tried this as it involves a more complicated procedure and the use of Ammonium iron (III) oxalate which is more toxic and more expensive than the chemicals used in the formula given earlier. I felt it was more problematic to use in a domestic environment; however, it is reported as having some advantages over the more common version.

There is also a brown version of ferric ammonium citrate and a comparison of the properties of both types is given in Mike Ware's book (see bibliography).

The two properties that are perhaps of most interest to us are that the green version gives a slightly higher speed of printing and gives a brighter blue than the brown version.

If you want to know more about this area of the subject consult Mike Ware's book (see bibliography) as it gives thorough and interesting descriptions of the history, the recipes used and the chemistry of the cyanotype process.

There are many different recipes given for the light sensitive solution in various books and on the Internet. They nearly all use similar proportions of the two chemicals ie roughly twice as much ferric ammonium citrate as potassium ferricyanide by weight. Although the proportions of the chemicals are pretty constant the dilutions given vary widely. As most recipes are quoted for use on paper I started out using Barbara Hewitt's recipe for fabric and have found that it gives beautiful results and a good colour on fabric and paper so I've used that one ever since.

Preparing the solution

➤ Shut the windows while you are handling the dry chemicals
➤ Put out the cat and the kids and take the phone off the hook
➤ Put on gloves, a dust mask and something to protect your clothes in case of spills.
➤ Work on a surface that can be wiped down when you are finished or put old newspapers down first.
➤ Get out the equipment and the chemicals you need

Weigh out the chemicals:

Work out roughly how much solution you are going to need for the fabric you are going to treat. The amount of solution you need will vary depending on the weight and fibre of your fabric.

Not surprisingly heavier fabrics absorb more solution than light ones. To give you a rough idea to start with you can use the amounts given below. These figures are based on fabric 114cm/45 inches wide. Since these are only guidelines I haven't differentiated between a metre and a yard in length.

If you are weighing out small quantities of chemicals, it can be handy to use paper cake cases (muffin cases). These can then be discarded with the other protective papers when you clear up.

Fabric	Approximate quantity of solution
Silk/viscose velvet - short pile	375ml / 13fl oz per metre/yard
Prima cotton - medium weight	140ml / 5fl oz per metre/yard
Silk habotai 10	70ml / 2.5fl oz per metre/yard
Silk Chiffon 3.5	35ml / 1.5fl oz per metre/yard

The basic recipe is as follows :

15g / 1/2 oz potassium ferricyanide plus 30g / 1oz ferric ammonium citrate to 250ml / 8fl oz warm water. Use either metric or imperial measurements.

Weigh out the appropriate amount of each chemical, with a dust mask and gloves in place. Then replace the lids on the containers and put them away.

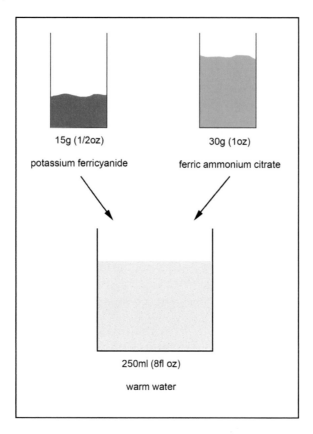

15g (1/2oz)

potassium ferricyanide

30g (1oz)

ferric ammonium citrate

250ml (8fl oz)

warm water

All the alternative photography books that I've read, say to mix each chemical in water separately and store them separately. The two solutions are then combined in equal quantities when you are ready to use them.

I've tried storing the solutions separately and in the combined form. The ferric ammonium citrate seems to grow slimey mold fairly quickly on its own but I've never had that problem when it's mixed with the potasium ferricyanide. I have no idea why.

Since potassium ferricyanide is light sensitive on its own and the purpose of the ferric ammonium citrate is to speed up the process and darken the end colour, I thought I would try producing a print with potassium ferricyanide alone.

After a very lengthy exposure of 2 hours on a hot sunny July day, I ended up with a delicate white image on a pale turquoise background.

Mix the solution

Measure out the amount of water you want to use then stir the crystals/powder slowly into the water bit by bit in a plastic or pyrex jug.

All solutions should be stored in well labelled glass or plastic bottles or other non-metallic containers. I found an old coolbox worked very well for storing bottles of light sensitive solution and treated fabrics as it was light-proof and was easy to carry round. HOWEVER, I don't have children visiting my studio who could confuse a coolbox with bottles of liquid inside for something to drink - use your common sense and label everything carefully.

After you've mixed your solution clear up your working space and wipe down the surfaces with a damp cloth - there are almost always particles of the chemicals that have 'escaped'. It's safe to remove your dust mask at this point but keep your gloves on until you've treated and dried your fabric to avoid getting the solution on your hands. This way you avoid, as with all dyes and chemicals, potentially developing a sensitivity to the solution. Prevention is definitely better than cure!

A frequent question is what form of cyanotype chemical/solution/treated fabric keeps best. My own experience is that:

➤ The powdered form of the chemicals will keep pretty much indefinitely **IF** they are kept cool and dark.

➤ I've used the solution after 3 months with normal, good results **BUT** it was stored in a cool, dark place.

➤ Treated fabric is much more difficult to store successfully **EVEN** if it's kept cool and dark. I usually wrap treated fabric in light proof fabric (the sort that you use to make blackout blinds) and store it in a cool place but it still has quite a short shelf life. After only a week it can start changing colour. You may still be able to use it but it may give you a pale blue image on a prussian blue background rather than the usual high contrast one.

Smooth backgrounds

Fabric loosely stretched on a wooden frame

Don't forget that the solution you've prepared is light sensitive, so coating and drying your fabric needs to be carried out in artificial light or indirect natural light. In my house it's the sort of place where my cat wouldn't lie; she likes warm, sunny places whereas cyanotype solution likes more shaded spots on the other side of the room. If the solution or your treated fabric starts turning blue then UV light is getting to it from somewhere!

Pour out enough of the solution for the amount of fabric you want to treat into a plastic or pyrex jug.

Using a frame
Since I don't usually prepare large quantities of fabric at a time I pin my chosen material on to a wooden silk painting/batik frame. My frames are made from four pieces of 2" x 1" wood glued and screwed at each corner but you could use an old picture frame just as well. Tear a piece of your fabric slightly bigger than the frame and pin it to the edges so it is supported and air can get to both sides to help with the drying process. Tearing rather than cutting keeps the grain of the fabric straight.

If you are using a frame to support your fabric, stand the frame on its end. Give the solution a stir just before you use it and, using a hake or other large, soft brush (or sponge), dip it in the solution, wipe the excess liquid off on the edge of the container, so it doesn't dribble, then paint the solution on to the fabric starting at the top and working down. Take your time and aim for an even coating. Don't get it so wet that it drips - this is just a waste of solution and can make an awful mess! Remember that the solution will 'travel' through the fabric after you paint it on so you don't need to paint right up to the edges. Also, try and avoid getting the solution on any metal pins you might have used as the solution may react with the metal and give you nasty, dark marks.

A variation on the frame method given above is to lay your fabric on to a smooth piece of plastic or glass. Tape the corners so that it doesn't move around too much, then paint the solution on.

Wash your brush or sponge thoroughly in water as soon as you've finished applying the solution and wipe up any splashes or spills, otherwise inconspicuous droplets of yellow liquid will turn into dark blue stains. If you do get blue stains on floors or surfaces then normal household cream cleanser will usually remove them.

You then need to leave the fabric to dry in a dark place. How dark is dark? Well, if it's a warm day and the fabric dries quickly a shaded corner is enough. If you are going to have to leave it for any length of time it will need somewhere genuinely dark. I use the bottom of a little-used airing cupboard, which has the added benefit of being warm as well as dark. You could use an old wardrobe with well-fitting doors. You can also use a hairdryer or fan heater on a low setting to dry the fabric but keep the airflow moving so it dries evenly or you may get unattractive tidemarks.

Immersion

If you want to prepare larger quantities of fabric in one go you can immerse the fabric into a bowl or tray of solution, let it soak in for a few minutes, then squeeze out the excess solution. Make sure the solution has been thoroughly and evenly absorbed, especially with large pieces of fabric. The solution can be concentrated in the folds of the fabric so move it around with gloved hands to get even coverage.

The treated fabric can then be dried in a domestic tumble dryer at the lowest setting. I found it took about 20 minutes for a couple of metres of medium weight cotton or heavy silk and as little as 10 minutes for very light weight silk. If you want a smooth background to your print then take the fabric out of the tumble dryer as soon as it's dry, otherwise the creases can give a really interesting texture to your background. Don't forget to wipe your dryer out thoroughly at the end to avoid getting blue stains on your next batch of washing. Also, if you have a glass door on your tumble dryer make sure it isn't in direct sunlight

Treated fabric can also be hung on a plastic clothes line to dry, again in a dark place. If you can arrange for suitable 'blackout' blinds in your bathroom you could fix a clothes line or airer over the bath with a couple of inches of water or damp papers in the bottom to catch any drips.

The advantages of using a frame are that the fabric is kept under light tension, it allows air to move all round the fabric, helping the drying process and it gives you something to hold other than damp fabric if you need to move the fabric about while it's wet.

If you are treating velvet, it's easier to paint the solution on with the fabric upside down ie on to the back of the fabric. The solution then wicks down the pile without distorting it.

Barbara Hewitt suggests putting the wet fabric through a wringer to remove excess solution. She folds in one direction, passes it through the wringer and then folds in another direction before wringing again.

At the end she passes a damp towel or rag through the rollers to clean off any residual solution that might contaminate later pieces.

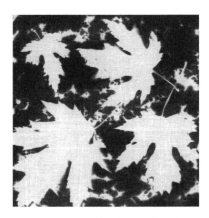

A textured background produced by sponging the cyanotype solution on to cotton

Textured backgrounds

The instructions so far have largely assumed that you want a smooth even background for your print, but textures and patterns can become an interesting element of your design. Here are some suggestions you can try.

➤ Apply the solution with rough brush strokes so that you can see the brushmarks when the fabric is exposed. This works better on heavier fabrics; the solution tends to flow along thinner ones, especially silk, in the same way that dyes do, but in this case you sometimes get nice crinkly edges to the dried solution.

➤ If you are drying your treated fabric in a tumble dryer, don't be in a rush to take it out when it's dry. The creases formed when it cools down will show up in the background of your cyanotype. I really like the textures formed in this way.

➤ You can also use kitchen roll, cotton wool or a sponge to dab the solution on with or you can drip or rag roll it on. All will give you different effects, some of which will please you more than others.

➤ Until the fabric has been exposed, moisture getting on to the treated fabric will leave a mark. This means that if you lightly spray your fabric with water either before you've placed your design elements or after, you will get a mottled effect on your background.

➤ If you put the fabric on a rough surface while you apply the solution and leave it to dry there, you will get a pattern on the background that reflects the roughness of the surface, rather like the effect of a brass rubbing.

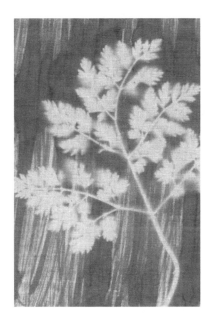

A textured background produced by dry brushing the cyanotype solution on to cotton

If you are lucky enough to get a warm, sunny day when you have time to do some cyanotypes you don't need to dry the fabric completely before using it: you can expose it while it's damp. This appeals to me as I'm not very patient but I just don't get enough hot, sunny days in the north of England to have much experience of this method. I can, however, say that you can get some very strange effects, including halos, using a sunbed with damp fabric which you may or may not like. **NB water and electricity together are not a good idea so make sure any damp fabric doesn't come into contact with anything electrical.**

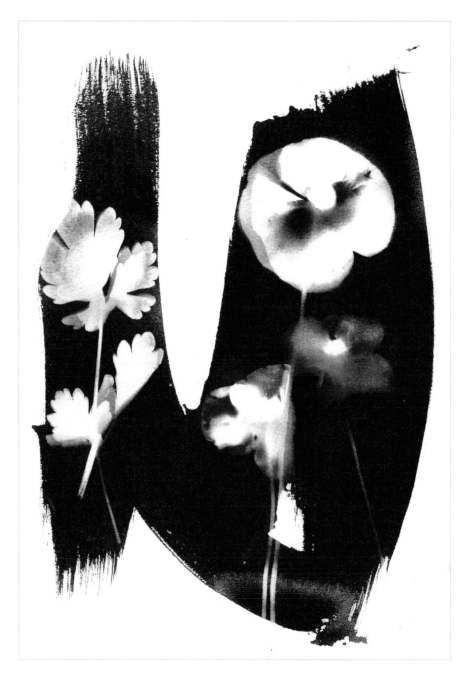

Although this book is primarily about cyanotypes on fabric I couldn't resist incorporating some examples on paper including this lively image by Mary Monckton.

Mary used a soft brush to swipe the solution on to Bockingford paper in random strokes. She picked the poppy flower and columbine leaf and then made a layered sandwich of hardboard, foam, paper with plants, and glass all held together tightly with bulldog clips and propped to catch the sun. As she works in New Zealand it took only a few minutes in summer to change from the green to grey colour indicating that the exposure was done. The paper was then thoroughly rinsed, dried and finally, pressed under boards overnight.

What a lovely result!

Opposite: cut glass jug on textured background created by leaving the fabric crumpled up while it dried.

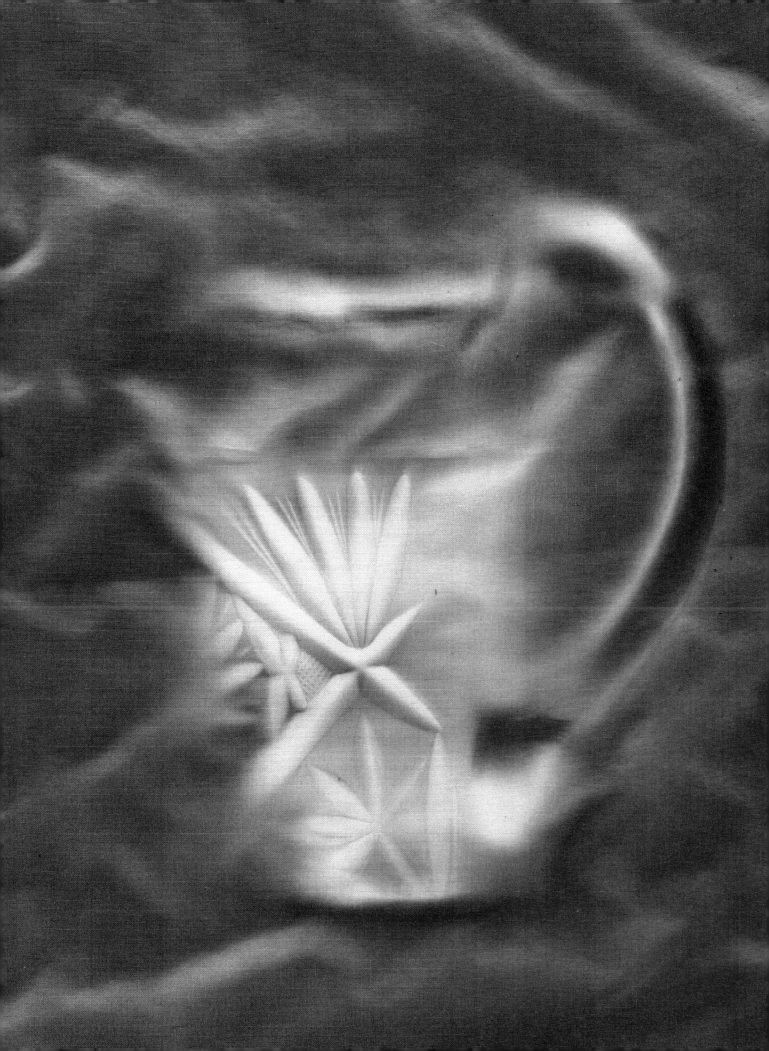

Using a resist

Outliner

You can restrict the area of the fabric you are going to print very precisely by using silk painting techniques.

Those of you who have done traditional silk painting will be familiar with using gutta/outliner (strictly speaking gutta is solvent based and outliner is water based but I'm going to use outliner here as a generic term).

An outliner restricts the flow of paint or dye on the fabric by forming a waterproof line. You can then paint within the line without the dye/paint spreading outside the shape. So, if you draw the shape you want to print with your outliner the cyanotype solution will stay within the shape you've drawn. This works best on thinner fabrics; on thicker ones the outliner doesn't always penetrate to the back so you may need to repeat the outliner on the back of the fabric, going over the design a second time.

To test if there are any gaps in your outliner, before you apply the cyanotype solution, paint clean water inside your outlined shape. Wet fabric is temporarily darker than dry fabric so you can see any leaks where there's a gap. If you do have a gap, dry the fabric thoroughly, apply more outliner to the gaps, let it dry, iron it to set and test again. Dry everything well before you apply the cyanotype solution. I used this method to produce the Cloud Bird shown opposite.

Other resists

A resist is something that stops the flow or penetration of a dye or paint on a fabric. The outliner described above is one but you can experiment with others. For instance in their book Photo Art, Tony Worobiec and Ray Spence describe a process called Photobatik which utilises the fact that oil and water don't mix.

One version they describe uses Vaseline to stamp an impression of a face onto paper. Cyanotype solution is then applied over the top. Since the solution is water based it doesn't adhere to the areas coated in vaseline and they remain white. After processing, the paper is washed in water with a little mild detergent to remove the vaseline. This could obviously be used on fabric and could be extended by using other design elements over the non-vaselined areas to create further patterns or textures.

If you are interested in using other resists the thing to consider is whether the method of removing the resist will damage the cyanotype. Don't forget that they are very susceptible to anything alkaline.

Sky bird
To produce the image opposite I first used black silk painting outliner to create the bird shape and then used steam fix silk dyes to produce the moon lit night sky, using alcohol to give the cloud texture. I then steamed the silk to fix the dyes.

I then applied cyanotype solution inside the bird shape - the outliner prevented the solution from migrating into the sky area.

Next I created an A3 negative of clouds, placed it over the bird and did the exposure, processing it in the usual way.

So, a cyanotype doesn't have to be the whole of a piece of work - it can be incorporated into a bigger image.

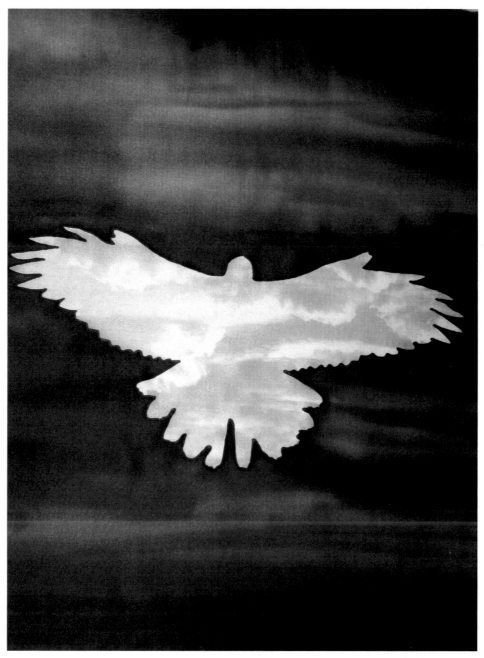

Storing your treated fabric

Once your treated fabric is dry then you can remove it from the frame, if you've used one, and carry on to produce cyanotypes straight away or you can store the treated fabric in the cool and dark for future use.

A good solution is to use the light proof bags that photographic paper comes in, as they are designed specifically for this purpose. However, now that digital photography is so popular these bags have become scarce. Bin liners, although they are black, do usually let light through. Hold one up to the light and you'll see what I mean. Alternatively, wrap the dry fabric in a plastic bag and then in aluminium foil or a foil bag. You could also wrap the treated fabric in light proof fabric which is what I usually use. However you keep the light away, the fabric needs to be cool, dry and dark.

Making the Prints ...

So, by now you have either bought some prepared cyanotype fabric or have treated and dried your own. You now come to the best bit, making the prints. I should perhaps add a health warning here - it can become a bit addictive (in the best possible way!)

As I said earlier, cyanotypes are created by placing something over the prepared surface, or manipulating the fabric in some way, to stop UV light from reaching parts of the light sensitive surface. There are many ways of producing a cyanotype image on fabric and they fall, more or less, into three groups.

First we have photograms. Most of the first cyanotypes were, in fact, photograms, made by laying items like foliage, flowers, algae, lace or feathers on to the prepared fabric before it was exposed.

Mike Ware makes a case for using the lovely word diaphane for anything other than a negative that blocks the light to make the image. However, in the textile world it specifically means a type of figured silk fabric.

For this reason I use Barbara Hewitt's more general term 'design element' to mean anything, including a negative, that is placed over treated fabric to form a design. It has the advantage, in this context, of not being ambiguous.

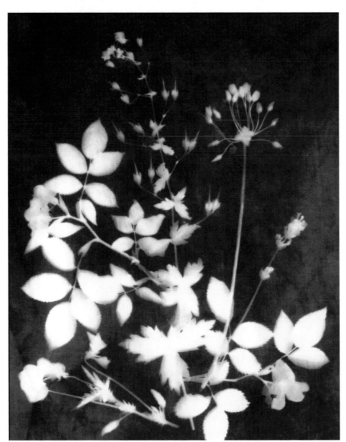

Left: Photogram on cotton of mixed flowers

Opposite: Silk dress with photogram by Barbara Hewitt
Photograph: Barbara Hewitt

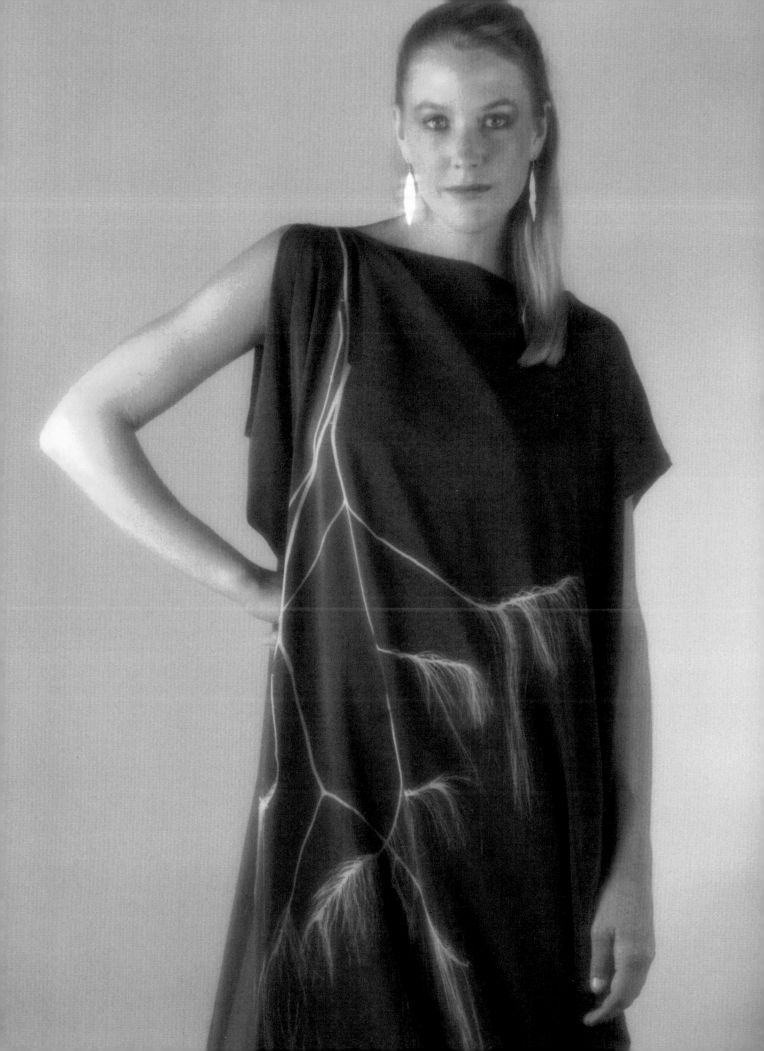

Secondly we can also use photographic negatives. These are placed on top of the fabric and act as a barrier to the light. They range from glass negatives from plate cameras to modern digital negatives printed on to transparency film using an inkjet or laser printer.

Cyanotypes are contact prints so the final image is the same size as the negative used to produce it. With a very modestly priced printer, digital negatives can be produced which are A3 size!

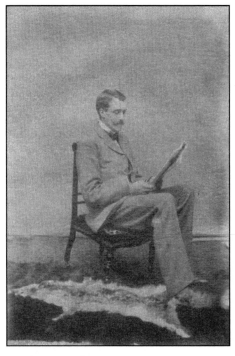

Gentleman reading
Glass negative onto silk

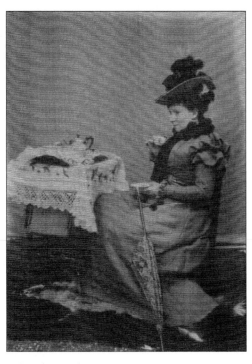

Lady with parasol
Glass negative onto silk

Glass negatives kindly provided by Sue Lowday

From a digital negative, created from a 35mm slide
Original photograph by Craig Burton

Thirdly, a bonus of being textile artists is that we are working with a very flexible medium, unlike paper or wood, which have also been used for cyanotypes. So, anyone who has used shibori has another range of techniques at their disposal for sewing, twisting, scrunching and clamping the fabric, before it's exposed, to create patterns and textures.

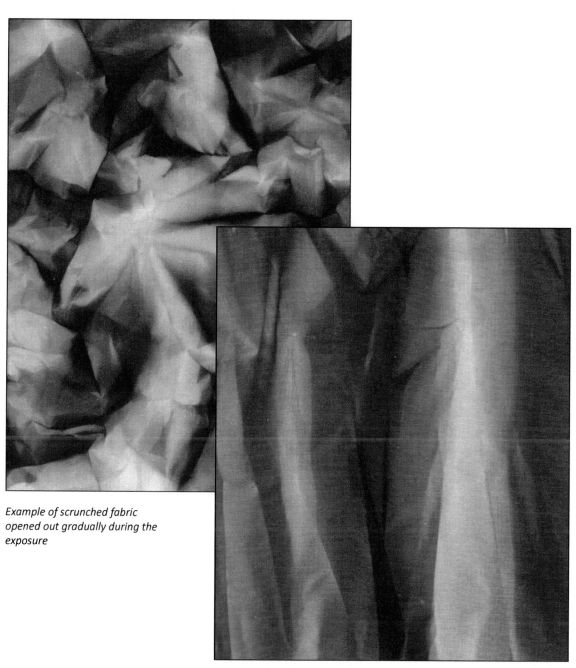

Example of scrunched fabric opened out gradually during the exposure

Example of twisted fabric opened out gradually during the exposure

We'll look at each of these groups of techniques in turn and then I'll suggest some ways that you can combine them.

Photograms

What's a photogram? Well, it's what you get if you lay a flower or other object over a sensitised surface and the shadow of the object makes the design during exposure to UV light - there is no negative or camera involved.

You can use anything that blocks light to make a photogram. Look for things with interesting edges such as ferns, brackens, flowers, leaves (especially sprays of small leaves), bamboo, insects, feathers and so on. A lot of weeds work well (see bottom left). Dried flowers and leaves can give some very nice effects.

Items like ferns, which have tiny fronds very close together, may benefit from carefully snipping out some of the fronds so that the beauty and intricacy of the remaining ones are more easily seen.

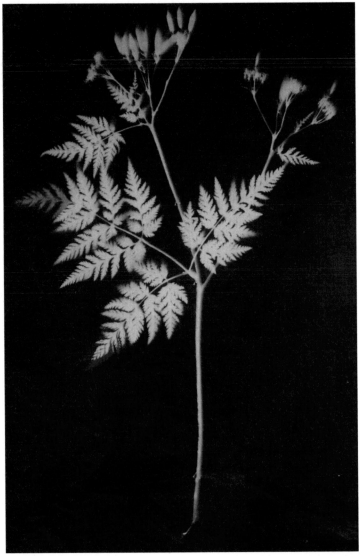

Photogram on cotton showing fishing net, lace, bubble wrap, hat brim stiffener and knitting yarn.

Photogram of weed on cotton

Photogram of Queen Anne's Lace on cotton

Opposite: photogram of clematis on cotton

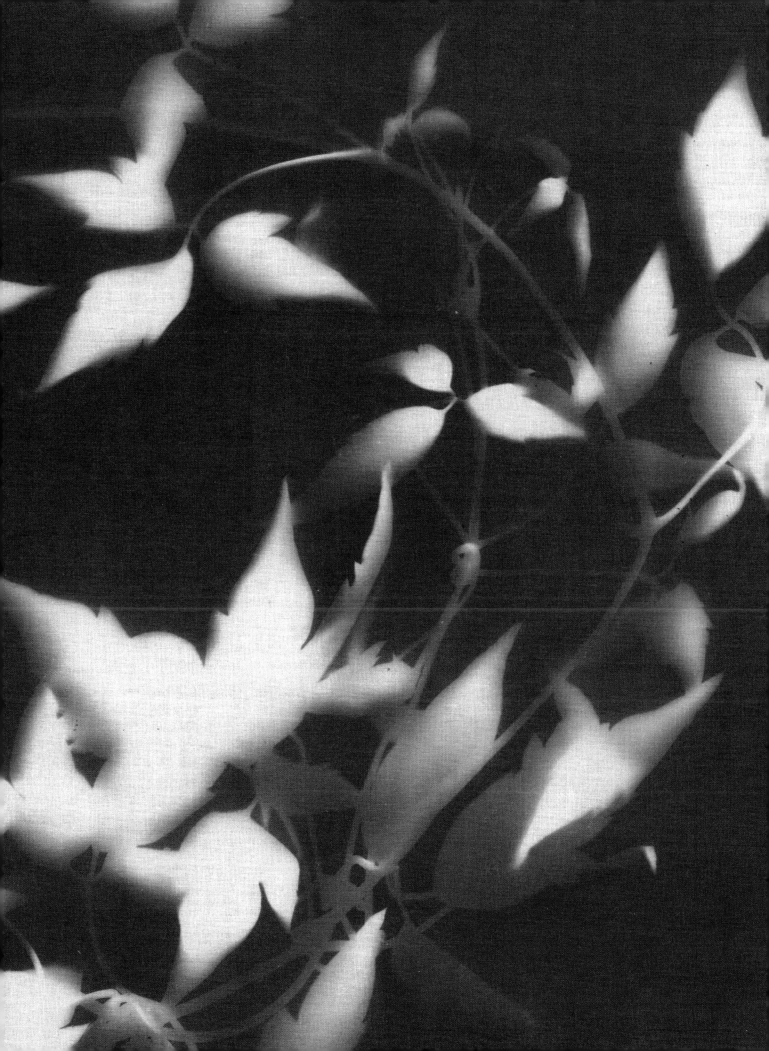

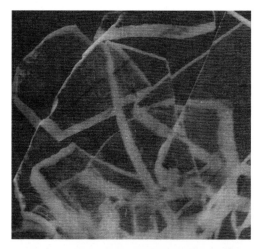

Look for things that are translucent or have translucent sections. Some flowers give beautiful, ethereal images but also try things like bubble wrap, sellotape or small pieces of glass (for the edges).

Left: shards of glass were piled onto a piece of treated cotton, using very thick gloves!

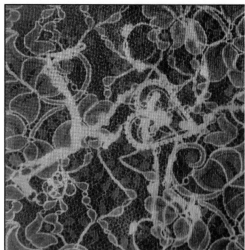

Intricate materials like lace, netting, chicken wire and open weave fabrics or knitting can give interesting textures in their own right and can make very good 'linking' elements in a design.

Left: 'Lace & Jewellery' by Mitch Phillips Cotton square 6 x 6 inches Objects used were a piece of lace and a foot bracelet from India. These were placed on a light box with treated fabric placed on top for 500 seconds and then the material was washed off in cold running water. Photograph: Mitch Phillips

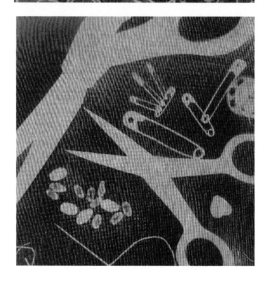

You can also incorporate items like stick-on letters, pasta shapes, small items like buttons, scissors, stencils, glasses, jewellery or small tools.

Left: 'Sewing essentials' by Mitch Phillips Cotton square 6 x 6 inches Scissors etc. were placed onto a light box with treated fabric on top for 500 seconds and then the material was washed off in cold running water.
These samples are part of a collection used to introduce her students to the wonderful creative world of cyanotype.
Photograph: Mitch Phillips

Just have a look round and see what you can find. I once had a student who is also a potter and he brought some clay to a workshop. He moulded shapes to use in his prints. Something else that occurred to me recently, which worked very well, was to sandwich some tomato ketchup between two sheets of transparency film and press down, making patterns with my fingers Then I thought what if I put some liquid between the sheets and then froze it.....

Pinning out

This is one of my favourite ways of preparing a cyanotype, giving beautiful, subtle, results.

Remember that design elements that have edges which are in close contact with your treated fabric will give a crisp image, whereas areas which stand slightly away from the surface will give a softer or 'ghosted' edge.

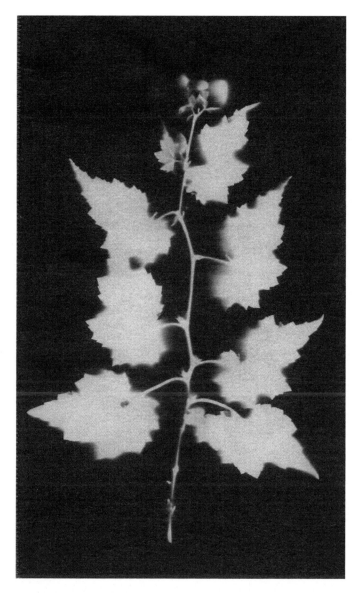

As you'll see from this photogram of a begonia, the outer edges of each leaf are fairly crisp since they were pinned down in close contact with the fabric. The inner edges, near the stems, were allowed to lift slightly off the fabric so the edge is softer or ghosted. The tiny flowers at the top were slightly transluscent so they appear softer as well.

These 'hit and miss' edges are, I think, why photograms of natural material appeal so much to me. Paper cutouts or a fern under a sheet of glass will produce a uniformly crisp outline but the natural spring and movement of a stem and leaves or flowers can be partly controlled and partly encouraged to produce something special.

For this process you will need:

➤ A support of some sort. I use pieces of polystyrene that are designed for insulating buildings. These are about an inch thick and are stiff enough to support your fabric but soft enough for you to push pins in easily. Barbara Hewitt uses fibreglass insulation board, removing the aluminium foil and covering it with newsprint or craft paper. See what is available locally; the only criteria are that it should be stiff enough not to bend if you want to prop it up, it should be soft enough to push pins in and it shouldn't have any surface which might come off on your fabric or show through thin fabric. It should also be easy to cut to size for a particular project.

➤ Your choice of treated fabric.

➤ Pins, I like using 'Sequin and Bead' pins best as they are short and fine. However, you may need longer ones for some design elements. Pins with glass heads are likely to show but this could add to the design ...

➤ The elements of your design.

First of all tear or cut a piece of your treated fabric and place it onto your support. Put a pin in at each corner to hold it in place, keeping the grain of the fabric reasonably straight. Don't forget that your fabric at this stage is light sensitive so you need to work in artificial/ subdued light and that any treated fabric you are not going to use straight away needs to go back into its protective packaging so it doesn't become exposed while it's waiting to be used.

Make sure your leaves etc are dry before you place them onto your treated fabric. Any drops of moisture on your fabric will leave marks. The ends of stems are particularly susceptible to ooze marks as the sap comes out. Place them between pieces of absorbent paper for a while to make sure they are dry. Alternatively put a layer of cling film between the treated fabric and the design elements.

Once you have dried and arranged your items then you can pin them into place. Place pins directly next to stems and leaves at an angle so that they 'lean' over the items (see the image on the right). If you look directly on top of your design, the pins should lie over the stems/leaves, not over the fabric. See page 10 for an example of this.

You can pin all round your items so that all the edges are close to the fabric to give a crisp image or you can leave some edges loose so that they stand away from the fabric to give a ghosted image. Be careful about pinning through fleshy leaves or stems as the sap can give nasty blotches on your picture. Also, if you pin across translucent petals or similar you may be able to see the pins - obvious when you think about it but I recently ended up with a strangely spikey picture of poppies. (see top right).

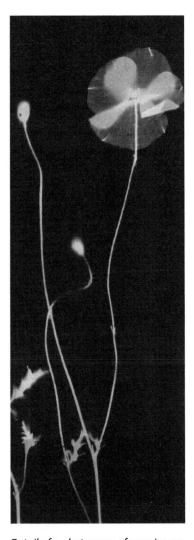

Detail of a photogram of poppies on silk, showing pin marks round the flower head

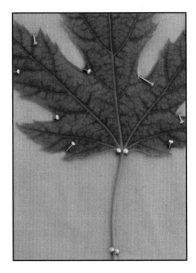

This image shows the pins holding the leaf down leaning at an angle.

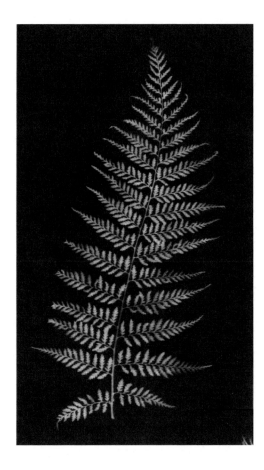

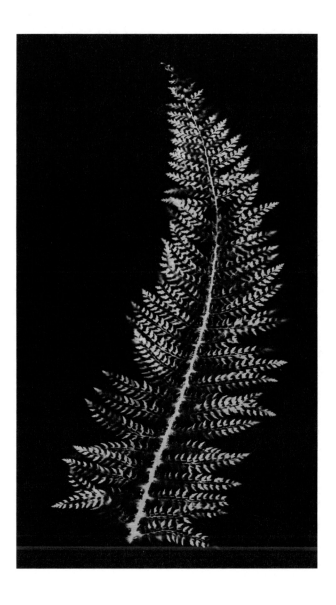

These two images show nicely the difference between pinning a fern down in selected places (right) to get a sense of depth and putting a sheet of glass over the fern to get more even detail (above). Which one you use is a matter of taste.

A few notes:

➤ If you haven't got time to do a cyanotype of a particular flower when it's in bloom then scan or photograph it and do the print from a negative later. The end result will be different but probably equally beautiful.

➤ While you are preparing your design materials on the sensitised fabric avoid direct sunlight but you can work in artificial light.

➤ If you're constructing a big design indoors, that you intend to expose outside in the sun, then make sure the base you're working on will go through the doorway!

➤ If you are using something like a sunbed to expose several cyanotypes at the same time, don't forget to cover anything you have finished preparing while you prepare the rest. I use light proof fabric that is sold for lining curtains and blinds to cover my 'work in progress' until I'm ready to expose it.

➤ If the leaves have a ridged back and you want a crisp image turn them over so that the ridged side is uppermost and the leaf lies closer to the fabric. Similarly, if you want to use a flower that has a deep back to it, turn it over and put it face down on the fabric.

Using sticky back plastic

After I'd written most of this section of the book I had a thought; if you want to hold delicate items in place but you can't use pins because they would show, could you use clear sticky back plastic upside down to hold them still? Well the answer is - yes, it works a treat. It holds delicate, translucent items in place, even in a stiffish breeze.

Cut a piece of this plastic slightly bigger than your fabric. This plastic has a paper backing which peels off to reveal the sticky surface. Lay the plastic upside down (ie paper side up) on to your treated fabric. Peel back a narrow strip of the paper backing and fix it to the support with masking tape. Repeat at the other end, then peel off the rest of the paper and tape the sides so that the plastic is flat and in good contact with the fabric. If you don't have something like masking tape, you can pin the plastic down but it's more difficult to get the plastic to lie flat.

You can then lay your delicate items down on the sticky surface and press down gently with your fingers where you want crisp edges on your photogram and leave loose edges where you want ghosted edges.

You can also lift the plastic off and place it over another piece of treated fabric to repeat the print if you want to. In the UK this plastic comes in rolls of up to a metre wide so you could lay out the design for a couple of metres of fabric and then lift it onto the treated cloth (with help!).

Since you can see through the plastic you could also draw out your design on to paper and decide where you want the elements of your design to be then lay the plastic, sticky side up, over the paper and lay the elements on to the sticky surface. You can then lift the plastic with the attached elements on to your treated fabric, tape down the sides and expose the piece in the usual way.

> *Sticky back plastic is a product sold in the UK for covering books. It comes in a variety of colours but also in a clear version which is the one that's useful here. It achieved cult status following its frequent use in a children's television programme called Blue Peter. Anyone who grew up after 1958 in the UK will probably grin at its mention.*

> *There is nothing to stop you combining the sticky back plastic with pinning if you want to use a mixture of types of item. So, you could pin stiff stems in place through the plastic.*

Glass/Perspex

Another way of keeping your elements in close contact with the treated fabric is to use a sheet of glass or Perspex on top. You make a sandwich of a piece of board or something stiff and a sheet of glass or Perspex. I often use a clip frame as these come with a board backing and a piece of glass cut to size with smooth edges. However, I use giant bulldog clips instead of the clips that come with the frame to accommodate the extra depth once you have included your design elements.

> *Some students have tried to do exposures in a conservatory but the window glass had a built-in UV filter to help stop the furnishing fabrics fading so it didn't work ...*

Anna Atkins is, perhaps, best known for her photograms of algae. Larry Schaaf tells how authors working at the same time as Anna Atkins described the method of preparing algae prior to printing.

The algae were cleaned and arranged before lifting them out of the water on a sheet of stout paper. They were then dried between sheets of blotting paper in a press. It is reported that this process worked very well for some species but that others stuck fast to their blotting paper support unless a layer of muslin was put over the example. This, however, had to be removed part way through the drying process as otherwise it left a pattern on the algae.

Schaaf surmises that the examples in Anna's book that were exposed while on oiled paper were too fragile to lift off the drying paper. The dried algae would be placed directly on the treated paper with an oiled, hand written label and a sheet of glass placed on top before the whole was exposed to the sun.

➤ The edges of the glass or Perspex will show in the print if the sheet is smaller than the fabric but these can sometimes be hidden by covering them with other elements of your design.

➤ Make sure that the glass or Perspex doesn't have a UV filter built in as this will slow down or prevent the exposure.

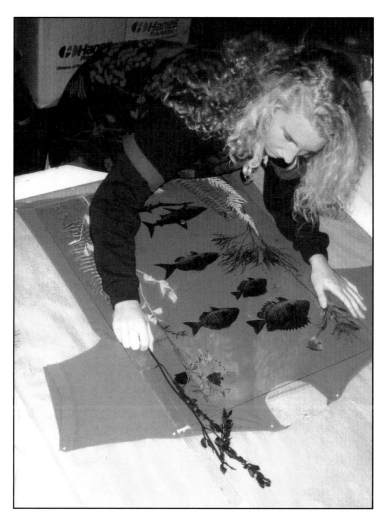

Glass edges being disguised with foliage
Photograph: Barbara Hewitt

Nothing

As long as you can expose your cyanotype with the support more or less horizontal and there's not too much wind around then you can just lay design elements over the fabric and expose them without having to fix them down in some way.

With some deep elements this is the only way to print them as they are too springy to be held in place by pins or sticky back plastic or too thick to go under glass. This photogram of a very spikey thistle is a good example; there is nothing in close contact with the fabric so the whole image is ghosted resulting in a weird, alien image that I really like. The glass jug on page 21 is another good example.

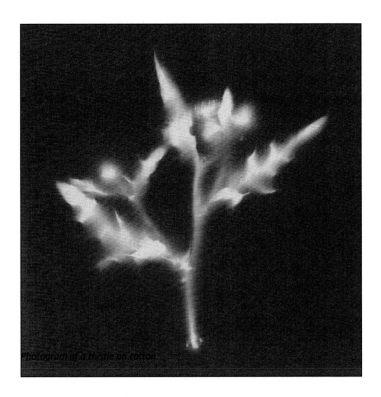

Photogram of a thistle on cotton

Lettering

You might like to add some text to your images and there are a number of ways to do this. Anna Atkins wrote the labels for her photograms of algae by hand on paper and then treated them with oil to make them more translucent. They were then laid over the treated fabric and other elements for her photograms.

Another variation is to write your text or labels on to a transparency using a chinagraph or other marker. Red or black is supposed to block the UV light best but anything that's opaque should be fine. You can also draw or write on a transparency using a chinagraph, oil pastel, markal stick (oil based paint in a stick), Tipex (whiteout) etc. Translucent media make areas of tone. If you want to use more powdery media like chalk, charcoal or pastels, try using a transparency specifically for inkjet printers as these have a slightly rough coating on one side which will help the pastel etc stay in place.

Another method is to use stick-on letters - there's a huge variety of lettering available for card making, so have a look at card making suppliers for sets of letters and other images. You simply peel these off the backing sheet and stick them on your fabric where you want the lettering to be. They block the light and the text appears after the fabric has been exposed. They usually wash off during processing but if you find some that have strong adhesive you can always stick them on to an transparency and use that as a negative.

Lastly, if you have access to a computer and printer, you can produce lettering using something like Photoshop Elements or Microsoft Word or a drawing package and, again, print on to acetate or thin paper.

Opposite: A fantasy print by Barbara Hewitt on cotton sheeting, 5' x 9', utilising lace curtain, paper, netting, film, confetti stars, cutouts and a lace table runner.
Photograph: Barbara Hewitt

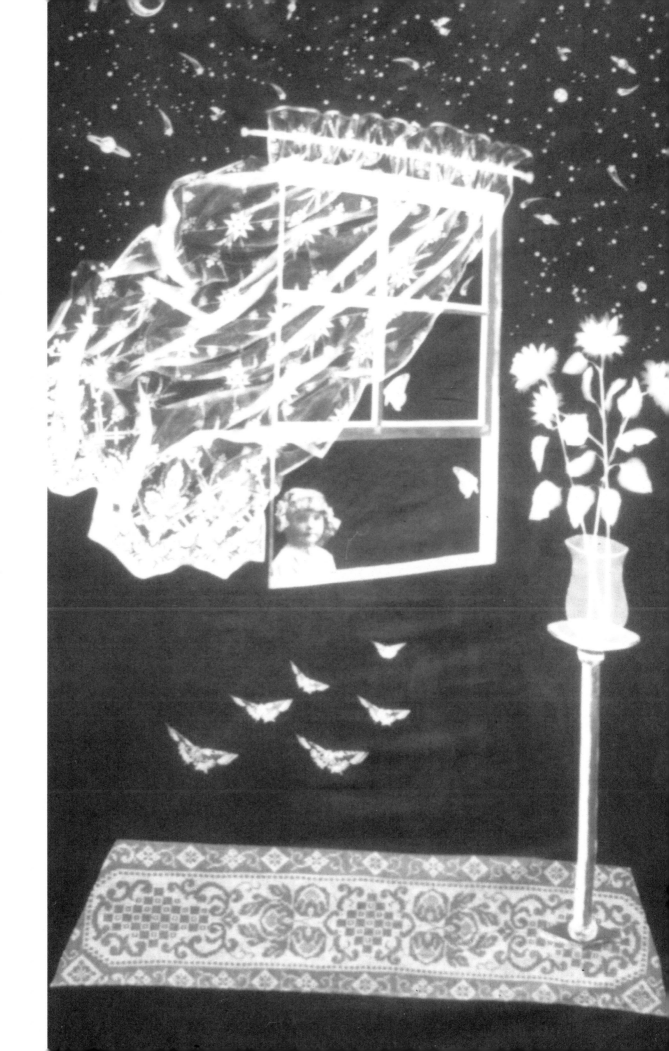

Using negatives

It really appeals to me to take a simple technique developed in the 1840s and combine it with the latest digital technology and various textile techniques to produce images on fabric.

The IT side has become much more accessible in the last few years; most households have a computer and printer of some sort and, now that prices have dropped dramatically, many also have scanners and digital cameras. Software has also become easier to use and more affordable. If you can wrench these away from other members of the family for a while then your cyanotyping options are hugely increased. Images can be captured and manipulated then printed on to a transparency which can then be used to create your cyanotype. All sorts of scrummy stuff which will, hopefully, become clear

The IT skills needed for this process are fairly basic; you need to know how to use a mouse and keyboard, start applications, open and save files and send a file to the printer. You'll also need to be able to find specific instructions for your software by using the Help files or a manual. The rest I'll explain as we go along.

You'll notice that I'm not giving step by step instructions for any of these processes as the precise details will vary from program to program and even from version to version but I'll try and give some indications of where you are likely to find a given function in the menus or help system. As I'm sure you are aware, IT changes very rapidly so although the information given in this section is accurate as I'm writing, it will probably have changed by the time you read it. However while the details may change the principles and ways of working should remain sound.

If you are fairly new to IT I'd recommend that you use the easiest method first until you become familiar with the general process then try some more advanced methods to get 'better' or different results.

* * * * *

To make any cyanotype you need something to block the light. In this section we're going to use a computer and printer to produce digital negatives. We'll then use them to block light and create a cyanotype photograph on your fabric.

> *Something old, something new, something borrowed, something blue......*
>
> *(sorry, I couldn't resist)*

> *I have to say that I am very territorial about my IT equipment. I worked for 20 years in IT and so did my husband. I put the longevity of our marriage partly down to having our own computers!*

So, what do you need?

This is difficult to specify precisely as hardware is improving and coming down in price all the time, but the basics are:

- A computer with plenty of RAM (memory)

- A camera and/or a scanner

- A printer

- Imaging/editing software eg Photoshop Elements

- Transparency film suitable for your printer. If you put inkjet transparency film into a laser printer it may well melt and wrap itself around the insides. If you put laser transparency film into an inkjet printer the ink will slide around and smudge. So, the right transparency film for the right sort of printer.

What sort of image will make a good negative?

First of all consider whether the picture you want to use will work without its colour. Try converting some of your existing pictures to greyscale (see how to do this below) and see what you like. Some will look bland and boring and some will be surprisingly good.

Not every beautiful picture will work well in mono. My husband used to work as a metallurgist and had some stunning transparencies of metal structures taken through a microscope. I wanted to use some of these to produce negatives. They were a wonderful mixture of unexpected colours and textures but many of them were very flat, tonally, when converted to greyscale. Altering the brightness and contrast improved things in some of the slides but many did not respond well.

You don't have to use the whole of an image; you can cut out (crop) a section of a picture and just use the bit(s) you like. You can also distort an image on your computer before you print it out or you could combine several images into a montage. These days the limits are probably your imagination and skill rather than the limitations of your computer and software.

After a while you'll get a feel for what you like. You'll probably find that images with good contrast ie the difference between bright and dark areas, or with a good pattern or texture, tend to work best but the only person you have to please is you. If you're happy with the image then use it. After all it's your work and you can do what you like.

> *I like Dan Burkholder's acronym; he refers to an image as being IWP (image worth printing)*

Creating negatives

There are several stages to producing a cyanotype with a digital negative - each stage is fairly straight forward but I would recommend that you read through the whole of this section first to get an overview of the process before you try it out.

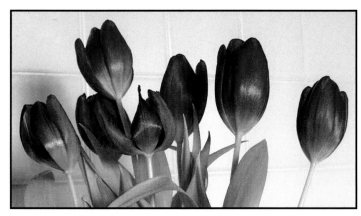

There are six main steps to creating a cyanotype from a digital negative. The sequence is:

1. First, capture or create your image and transfer it to your computer.

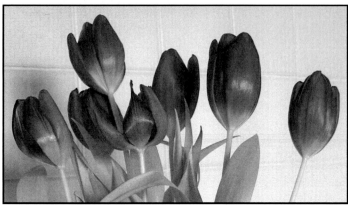

2. Convert it to greyscale ie take the colour out.

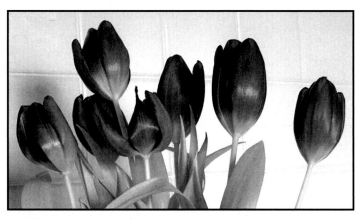

3. Manipulate the image - make it the right size for the transparency you are going to print it on and probably adjust the contrast.

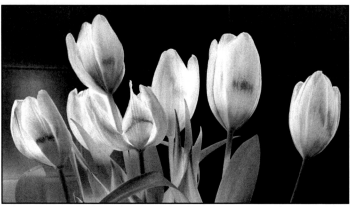

4. Invert the image to make it negative - this simply reverses all the tones in the image and makes the blacks white, the whites black and so on.

5. Print the negative on to transparency film or paper

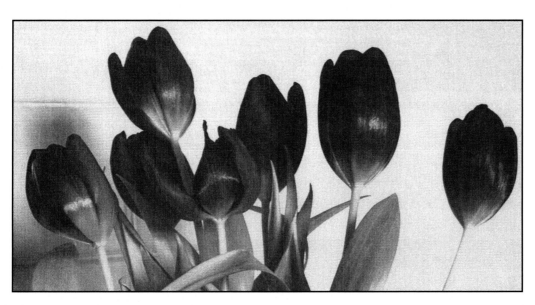

6. Produce your cyanotype in the usual way.

On the next two pages I've included a section on resolution. If you're not very confident with IT you can certainly miss this out for now while you're getting your head round the other stuff but do come back to it at some point as it will certainly help you to understand what is going on and to make informed choices as your work develops.

Obviously this book is primarily about cyanotypes and fabric so I can only skim over the following sections. If you are interested in digital imaging then have a look at my book 'Digital Imagery on Fabric', or my online 'Creative Computing' course.

Let's have a look at each step in the process in a little more detail.

1. Capturing images ...

The first thing you need to do is get your images into the computer and there are a number of ways to do this:

You can take photographs with a digital camera

These are then downloaded to your computer via a cable or by putting the memory card from your camera into a card reader that plugs into your computer. The details of how to download images to your computer will vary from camera to camera so consult the documentation that came with your model. Generally, there is some software which needs to be installed on your computer and, typically, a cable which goes from a USB port (socket) on your camera to a USB port on your computer. You should then be able to view the pictures that are on your camera's memory card and decide which ones to transfer (download).

If you are uncertain what part of a scene to take a picture of, take all of it. You can always select different sections of it on your computer and decide later what you want to use and what you want to discard.

I like the phrase 'capture your image' as it conjures up mental pictures of going on safari with a butterfly net....

Resolution

Resolution means different things in different contexts. It's like the word 'print' - that can mean something produced using a screen printing method, something produced by a printer connected to a computer or something produced in a darkroom from a photographic negative. They are all sort of 'picture' things but basically are quite different. Resolution is like that, so I'll take each type in turn and explain what it is.

Image resolution:

Digital pictures, whether scanned or taken with a digital camera, are made up of picture elements (pixels) - they are the building blocks of a digital image. Imagine that an image is made up of a grid of tiny squares - each square is a pixel and contains information about the colour and brightness of that part of the image. When the picture is sent to a monitor, to be displayed, or to a printer, then the device converts this digital information into a visual representation of it.

Detail of a digital photograph, enlarged to show individual pixels.

Image resolution simply refers to the number of pixels in an image. A lot of pixels means a high resolution image, a small number means a low resolution image. High resolution images have more detail, less graininess and more subtle transitions of colour and tone.

A mid-range camera, at the time of writing, will capture 10 megapixels, that is the sensor in the camera splits the picture into 10 million pixels, each recording a tiny section of the picture. In any digital camera, taking pictures at its highest resolution setting will split the picture into more pixels than at a lower setting and will capture more information about the picture. This results in a sharper, more detailed picture, especially when it is enlarged.

By the way, the megapixel number in a camera's specification is derived by multiplying the width of the image in pixels by the height of the image in pixels. At its highest resolution my somewhat elderly digital camera produces an image 3456 pixels by 2304 pixels or 8 megapixels.

Monitor resolution:

This refers to the number of pixels that can physically be displayed by the monitor. My main monitor can display a maximum of 1280 x 1024 pixels. As it is approximately 15" wide that works out at roughly 85 pixels per inch (ppi). I can change it to a lower setting if I wish but not to a higher one.

Printer resolution

An inkjet printer works by squirting minute droplets of ink onto your paper and part of the specification of the printer is its maximum resolution, usually given in dpi (dots per inch) but each droplet of ink does not equate to a pixel of your image. In fact Tim Daly in his book 'The Digital Printing Handbook' suggests that in order to get a more realistic figure you take the quoted resolution for your printer, eg 1440, and divide it by the number of ink cartridges in the printer eg 4 (cyan, magenta, yellow and black). This gives

360 dpi. This figure is the highest number you should use in the Image Size dialogue box (see below) for the resolution you are going to print at, as your printer simply cannot print at a higher resolution whatever you feed to it. Increasing the resolution you print at over and above this figure will simply slow down processing and printing speeds and may even reduce the quality of the printed image.

Print resolution and resizing

When you resize an image, prior to printing it, you will usually see two sets of dimensions - in Photoshop Elements this is in Image > Resize > Image size. The top box refers to the image size in pixels. The bottom box refers to the Document Size that is the size the document will be when it's printed. This is made up of the width and height of the image in pixels plus the print resolution (not the printER resolution).

The resolution you print at will determine how big each pixel of your image will be when it's printed. Say you have a digital image 1000 x 500 pixels. If you print it at 100 dpi it will produce a print 10" by 5", ie the number of pixels on each side divided by the resolution. If you printed the same file at 200 dpi then the print would be 5" by 2.5". It's still the same number of pixels but each one would be squashed into a smaller space when printed.

I've given instructions here for Photoshop Elements but other software should have similar options.

If you'd like to see how this works, make a new image - File > New > Blank File - and set the size to 1000 by 500 pixels. Open the Image Size dialogue box - Image > Resize > Image Size and make sure the Resample Images option is off. Taking our image of 1000 pixels by 500 pixels change the resolution setting to different numbers and see how the print size changes. THE NUMBER OF PIXELS DOESN'T CHANGE BUT THE SIZE OF EACH PIXEL WHEN IT'S PRINTED DOES. If the print resolution is low the image will spread out over a greater area and each pixel will be bigger. It follows therefore that if you have a low resolution image (one with a small number of pixels) and you want to print a big version of it then each pixel will be big and the image may look grainy or jagged.

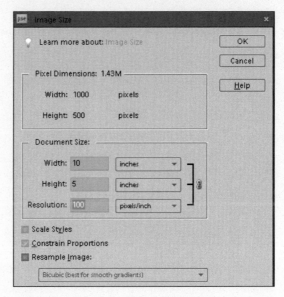

Now click on the Resample box and again change the resolution - this time the dimensions don't change but the number of pixels in the top box does. What is happening is that the software is inserting pixels to make the numbers right. It is guessing - this is called interpolation (lovely word).

To get the best quality image it's best to use the original pixels taken by your camera or scanner, that is without resampling, rather than the ones interpolated by the software. HOWEVER, as I've said before, we are printing on to a broken (woven) surface so we can often use a lower quality image without much detriment. Use your own judgement - do you like the result you've got? If so, go with it - your intent is more important that having the ultimate in 'good' images. Sometimes good enough is good enough.

Lastly, there's another box in this dialogue that you should be aware of, this is Constrain Proportions. If this is checked then when you change one dimension the other one will scale in proportion so that the image isn't distorted. If you want to distort an image, perhaps to make a banner print, then uncheck Constrain Proportions and you can change one dimension without the other being affected.

You can use a scanner

This is a very powerful and easy to use method of capturing images that is often under-estimated. Scanners available for home use are usually referred to as flatbed scanners as they have a flat plate that you put your item on to be scanned and then a lid that keeps the ambient light out.

Obviously you can't pick up a scanner and point it at a landscape like a camera (although this does create an interesting mind image!) but it does work in a very similar way. Instead of having an image sensor it has a scanning arm which travels across the item to be scanned and records rows of pixels of information. One advantage is that the lighting is supplied by the scanner itself and is very even so you don't have to worry so much about the light around you creating unwanted shadows or harsh highlights. A scanner also has a short depth of field so even if you leave the lid up to scan a 3D object the surrounding room won't impinge on the object.

So, what can you scan? Well, it's almost easier to say what you can't scan. There is, of course, one restriction; the biggest object or picture you can usually scan is A4 size, ie the size of the bed of your scanner.

You could try:

➤ Photographs - these are the obvious things to start with. Most people have albums with their family history in (or in my case several boxes - they haven't quite made it into albums yet ...)

➤ Transparencies (slides) - many quite cheap scanners these days have attachments to scan transparencies.

➤ Artwork - drawings, paintings or just doodles by you or your children.

➤ Objects - old maps or letters could be used, or perhaps hand made paper or rusty metal. Try shells or other 3D objects. If you are scanning an object with sharp edges, it's a good idea to put a transparency film on the scanner bed to protect it.

➤ Some intriguing effects can be achieved by laying soft flowers directly on the scanner, like the bluebell on page 8. If you are using fresh flowers or foliage on a scanner put a transparency down on the scanner bed first - it will stop any drips of sap or water messing up your scanner. You could also try scanning your favourite fabrics.

You can use a drawing package

This is a software programme on your computer with which you can draw as you would with a pen and paper but using a mouse, or a drawing tablet, and your monitor.

You can use Clip art

These are pictures that you buy on a CD or download from the Internet. They are often quite basic and cartoon-like but quirky. They are often free!

Depth of field refers to the amount of a picture that is in focus. For instance, in a landscape the trees close to you might be in focus but those farther away might be out of focus (fuzzy) - this is a short depth of field.

An exception to the A4 size restriction is if your scanner has the facility in its software to stitch separate scans together. With my own scanner, for instance, I can scan, say, an A3 image in two sections then the software will match them up and combine them into one image - cool, huh! This is sometimes referred to as a panorama maker.

2. Convert your image to greyscale

After I've made a working copy of the picture (see below), this is always the first thing I do with an image I'm thinking of printing a cyanotype from. Once you have taken the colour out of a picture you get a good idea if that particular image is going to work in mono.

Virtually all image editing software will have at least one menu option for converting to greyscale. For instance, in Photoshop Elements you could use the 'Mode' option under the Image menu but you'll have more options if you investigate the 'Convert to Black and White' option in the Enhance menu. Have a look in the Help system for your software for information on this.

3. Manipulate the Image

A photograph of a piece of metal taken through a microscope on the left and then the same image converted to greyscale on the right.
Original photograph by Iain Brown

Storage and filing

I would strongly recommend that you set up a filing system for your images so you can find them again easily. I usually keep mine in subject folders so I have, for instance, a folder for birds and insects, another for marine subjects, one for textures and patterns and so on. These are an archive for my original, high resolution images and are NEVER to be worked on. (OK, I have occasionally started working on an original by mistake in a fit of enthusiasm but, luckily, not too often!) When I want to use an image then I copy it into a project folder and work on it there. That way, if I make a real mess of what I'm working on I can simply go back and get a fresh copy.

Crop

On most of the photos I take there are bits around the edge that I don't really want to include or there might be just one flower that I want to use from a photo so I use a software tool to crop, ie cut out, the bit of the picture that I want to retain. This usually involves selecting the appropriate tool and then dragging, using the mouse, from the top left of the section you want to retain to the bottom right of the section. The borders of the crop box can then often be dragged up and down or across to adjust the area selected. Look in your software help file for precise instructions.

Resize

The next thing is to make sure that your image will fit on the transparency or paper you are going to use. Imaging software usually gives two sets of dimensions for an image. One is the actual image size in pixels.

The other, often called the Document Size, is the size it will be when printed at the given resolution and is measured in inches or centimetres. See the section on resolution on pages 42-43 if you want to know how these fit together. You can make your image bigger or smaller by altering the dimensions in the Document Size dialogue box. Usually, if you change one dimension, eg width, then the other one will change automatically keeping the correct proportions.

Adjust brightness and contrast

You may well want to increase the contrast in your image since the process of printing a cyanotype tends to decrease the contrast. It's often necessary to increase the contrast of an image beyond what looks right on the monitor.

The simplest way is by using the slider in the Brightness/ Contrast dialogue box, dragging the slider with the mouse in one direction to increase the contrast and in the other direction to decrease the contrast. If you've used the 'Convert to black and white' option to convert your image to greyscale then you'll find a contrast slider there too.

4. Invert the Image

Next you need to produce a negative so that, when you print your cyanotype, the tones of the cyanotype will be true to the original image. There is an option in most imaging software to do this. For instance in Photoshop Elements it is in Filters > Adjustments > Invert. It simply reverses all the tones in the image so that black becomes white, white becomes black and so on through all the shades of grey.

You might like to try producing your cyanotype from a positive image printed on a transparency rather than from a negative image. Landscapes can come out looking quite gothic and moody and flowers look ghostly. One of my own favourite cyanotypes is of the tulips I've used as an example in this chapter, printed from a positive image. So the dark tulips actually come out as white flowers in the print.

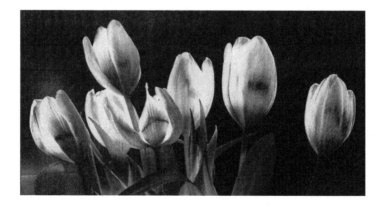

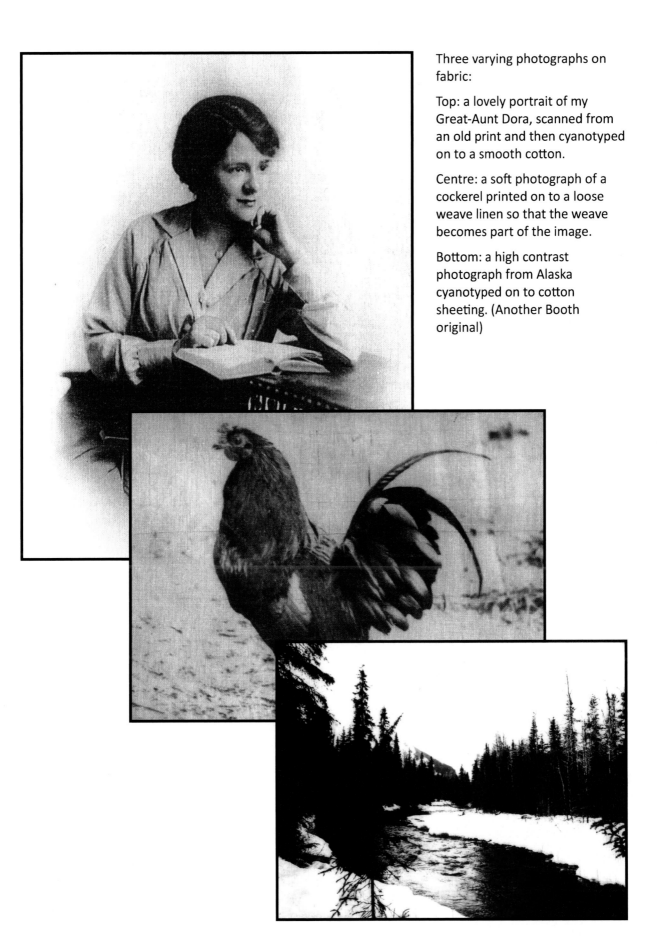

Three varying photographs on fabric:

Top: a lovely portrait of my Great-Aunt Dora, scanned from an old print and then cyanotyped on to a smooth cotton.

Centre: a soft photograph of a cockerel printed on to a loose weave linen so that the weave becomes part of the image.

Bottom: a high contrast photograph from Alaska cyanotyped on to cotton sheeting. (Another Booth original)

Printing the negative

Print quality depends on a number of factors:

➤ The type of ink used and the type and quality of the paper/transparency/fabric you are printing on.

➤ The quality of the printer.

➤ The settings in the software controlling everything, ie the selections you make in the printer dialogue box.

Each printer has a different dialogue box with different options. Generally, better quality printers will have more options and finer control so read the manual that came with your printer and get to know your own model.

This is the printer dialogue box for an Epson D68 inkjet printer.

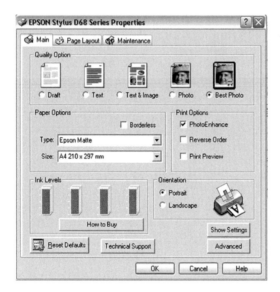

As you can see, there are options for choosing the Quality the printer is going to use - the top row of the box. Don't always assume that you need to select Best Photo. We're cyanotyping on to a broken surface so, usually, printing the negative on the Photo setting is fine.

The next row down includes paper options, sometimes called Media Options. Here you can select the type and size of media you are going to print on. Surprisingly the transparency option is rarely the best one as it is designed to put down a fine layer of ink so it's less likely to smudge. However, for a negative we want a dense layer of ink so that the light doesn't go through it. Try something like the Matte Photo setting or Glossy Film as these seem to work well. You may have to do some testing with your own printer to find the best setting for this purpose.

Basically, whatever your printer dialogue box looks like you need to find and select the appropriate size, orientation and media type as well as the appropriate quality option.

Another option you may like to play with is whether you print your negative in colour or in black. It may seem more intuitive to print a greyscale negative in black but the general recommendation is to print in colour as the combination of mixing the three coloured inks gives a denser result. I've tried printing the same negative in both black and colour versions and I've liked the cyanotype printed from the colour version best.

What are you going to print your negatives on?

The most obvious thing to use is a transparency that is suitable for your type of printer. Those for laser printers are designed to withstand the heat generated by the process whereas the ones for ink jet printers have a roughened surface for the ink to adhere to without smudging. If you put an inkjet transparency into a laser printer it may well melt and do nasty things to your printer's insides!

There is usually a right and wrong side to transparencies; those for laser printers often have a paper strip down one side as an indicator, while those for inkjet printers are usually rougher on one side than the other. You print on the rougher side.

Transparencies are not the only thing you can use to print digital negatives. Thin paper such as tracing paper can work. Anna Atkins used to hand write labels on paper and then oil them to make the paper translucent so you could try that but be aware that they will probably take longer to expose than transparencies. You might ask, since transparencies are so readily available, why would you produce a paper negative? Well, many inkjet printers have an attachment to take a roll of paper as well as cut sheets so, assuming your computer can handle big files, you could produce a negative several feet long. As far as I know inkjet transparencies of this size aren't easily available.

Hand drawn negatives

Most people associate negatives with a photographic or digital process but there's nothing to stop you creating your own hand drawn negatives either on paper or transparency film. I sometimes use a Sharpie to draw straight on to film but have also tried dry media like charcoal which work well on the rough side of inkjet transparency film.

If your negative is printed on an inkjet printer remember that the image on the transparency will be susceptible to smudging for a while after it comes out of the printer so leave it for a few minutes before you use it for your cyanotype. Depending on the ink it may also be damaged by water so keep it in a protective sleeve when you're not using it with a sheet of paper over the printed side so that the ink doesn't stick to the plastic.

Keep this in mind if you are cutting out the transparency image - you need to have dry hands or the image could smudge.

Paper negatives will need extra exposure time - I found that a negative printed on to tracing paper needed about an extra 30% exposure time whereas an oiled paper one needed about twice the time that a transparency takes. These are only guidelines as timing will vary with the type of paper used etc.

6. Creating a cyanotype from a digital negative

When you come to make a cyanotype from your negative then it wants to be in good contact with the treated fabric to avoid light getting underneath and fuzzing the print, so putting it under a sheet of glass or Perspex is a good idea. A clip frame will do the job nicely - it already has a backing and a piece of glass with a smoothed edge - but rather than use the fiddly clips that come with the frame I find bulldog clips easier. For bigger pieces you can use a piece of hardboard with a sheet of plate glass -ask your glass supplier to smooth the edges for you.

It can help to make a good contact with your negative if you put a layer of thin felt or rubber under the fabric/ negative sandwich.

There are a number of ways to get a transparency to stay in close contact with your fabric. Some you might like to try include:

> Using 505 Spray (a temporary adhesive for fabric. Don't get it mixed up with 606 spray which is permanent!), or Spraymount on the underside of your negative. Spraymount is sold as a temporary adhesive. Lightly spray the underside of your negative, wait for the spray to lose its shine, and press onto your fabric. NB read the safety precautions on the tin before you start.

> You can buy transparencies that are already sticky on the back - you just need to peel the paper backing sheet off after you have printed your negative and stick it on the fabric. These work very well but are more expensive.

> If you are using sticky back plastic (see the section on Photograms earlier in this chapter) this will, of course, hold negatives in place as well as other design elements but it doesn't always lie as flat as you might like for a really close contact with the fabric.

> If your negative is dense enough then you can even pin it in place on your fabric. Push the pins through the transparency/ fabric/support so that only the head is visible, choosing places when the ink is darkest. If it's done carefully, the pins shouldn't show in the final cyanotype.

However you are going to get your negative in close contact with your fabric you may want to avoid seeing the edges of the transparency - these will normally show up as ghosted edges. If your image is suitable you can cut round it and just use the cut out section to print your cyanotype as I did in the dragonfly image on page 59. Alternatively you can use other design elements over the edges to disguise them.

A nice 3D effect can be obtained by placing objects on top of the glass. Since these are lifted off the surface of the fabric by the glass, the object on the glass will look ghosted. Taking this idea further, you could have a negative and flat objects under the glass and other objects on top of the glass to give a layered image.

Opposite: lizard cyanotype produced from a digital negative.
Original photograph by Tony Booth

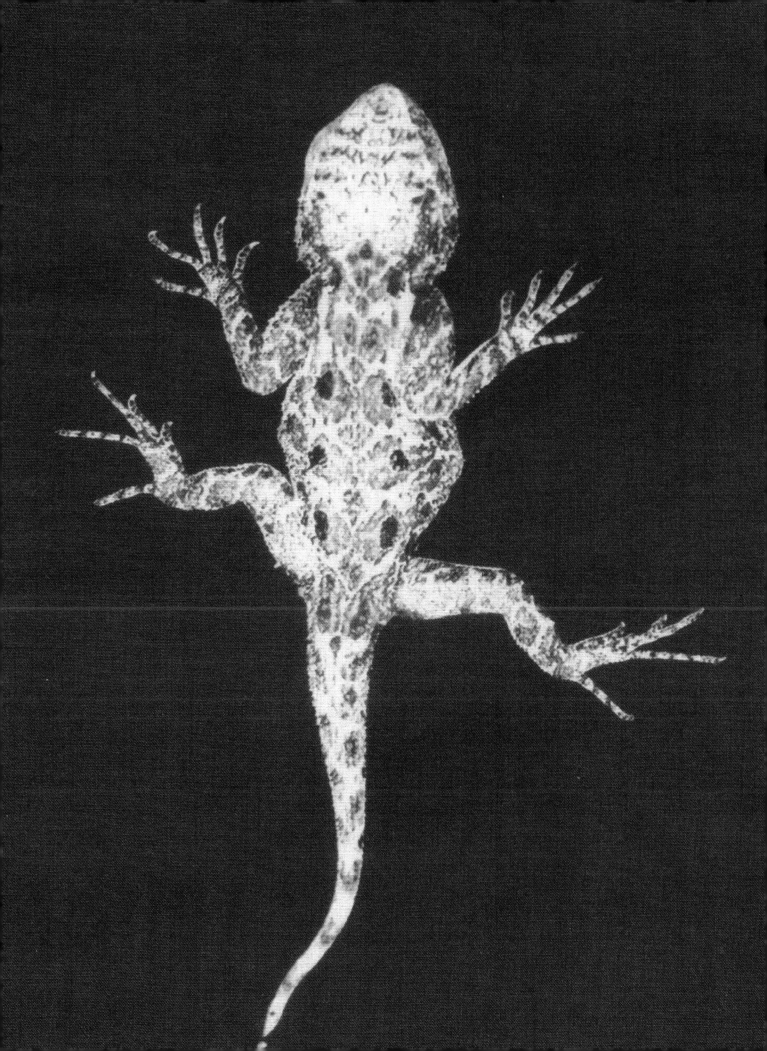

Hannah Lamb

Baptism tryptic by Hannah Lamb

2014 - 73cm x 90cm each

Cyanotype, hand stitch, appliqué, metal thread, silk, cotton

'Baptism' explores the euphoric experience of cold water swimming. The primeval draw of water and ancient symbolism of ritual and spiritual cleansing are evoked through personal observations; feeling exposed yet empowered, connected with nature, the visceral, sensual awakening of the body traced as shimmering marks on the surface.

Baptism was selected and exhibited in the 62 Group Exhibition 'Ebb & Flow' in 2014.

Detail of left-hand panel

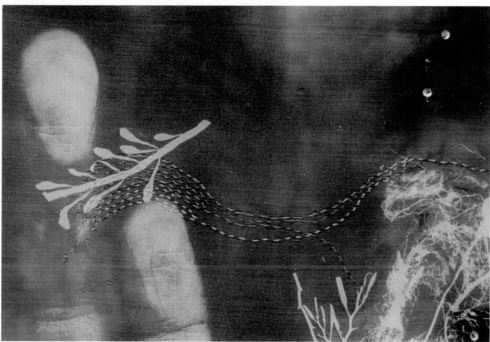

This detail from the central panel of the tryptic shows some of the delicate stitch work that adds so much to these evocative prints

Detail of right-hand panel

Cathy Corbishley Michel

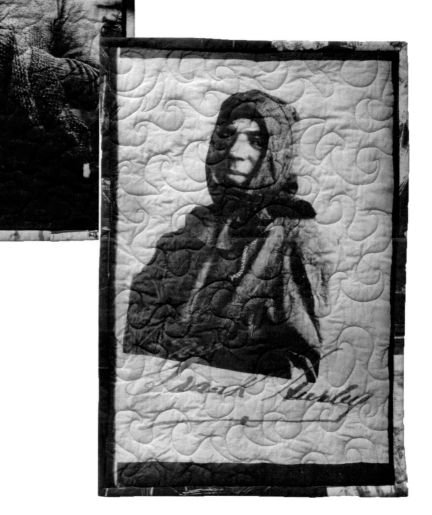

From photographs by Frank Hurley from Shackleton's Endurance (Transantarctic) Expedition (1914-1016). Both A3 size. Machine quilted.

Left: John Vincent (Bosun) mending a net.

Below: Frank Hurley.

Terra Nova 2, The Scientists (2014) – Opposite:

Original photographs by Herbert Ponting taken on Robert Falcon Scott's Terra Nova expedition to the South Pole (1910-1912). 36" x 54" (92cm x 137cm). Machine pieced and quilted.

Manipulate the fabric

Since we are using a flexible base for our cyanotyping we can use techniques that are not available to those using paper, card, wood etc. We can use Shibori which is a group of techniques that involve manipulating fabric before it is dyed to create a design or pattern. Methods include sewing, twisting, clamping, tieing and pleating. For suggestions of books that cover these fascinating techniques see the bibliography.

We can use some of these techniques with fabric and cyanotype solution. Those of you who are new to shibori might like to try one or two of the following suggestions.

Twisting

This method gives lovely, bark-like patterns - see page 27 for an example.

Take a piece of treated fabric and twist it lengthwise quite tightly. Pin either end to a support to stop it unravelling. You will need to turn it round periodically during exposure so that each side of the roll gets its share of UV.

> *Traditionally the twisted fabric is wrapped round a pole or pipe before being dyed. This obviously wouldn't work very well here as the side facing the pole wouldn't be exposed.*

My favourite pieces using this method have been unwound gradually during the exposure so that, after processing, there is almost no white left.

Scrunching

The patterns formed with this method vary from crystal-like formations to something like a pattern of pebbles and small stones - see page 27 for an example.

Simply take a piece of treated fabric and scrunch it up, gradually opening it up during the exposure. I usually start opening the fabric up around half way through the exposure and aim to have it completely open for the last five minutes or so but this is only a rough guide.

Stitching

If you've ever accidentally left a bit of thread on the surface of your cyanotype you'll know how even a really fine piece of thread will leave a mark on your print. So, any form of stitch will show up and you can, of course, use this to your advantage.

Shibori plus ...

You can get results with these methods that have a somewhat different character to the equivalent dyed fabrics. However, if you mix these techniques with photograms or with negatives then you have some unique options. Try adding some foliage or interesting objects to your fabric during the opening out process. The colour and pattern you get will depend on when and where you place them.

Opposite: for this image I pinned clematis on a central panel and then scrunched the fabric on either side. I then opened out these side panels at intervals during the exposure to give the pattern and variation of colour. This is on silk viscose velvet.

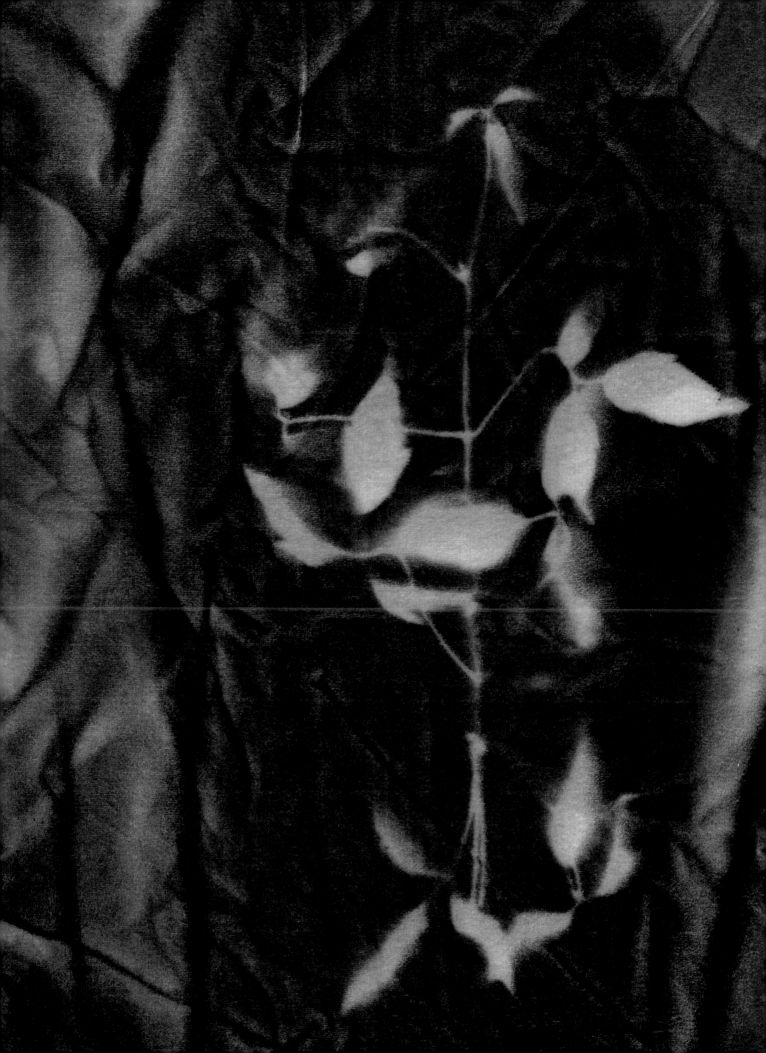

Putting it all together

Some of my favourite cyanotypes have been the result of combining more than one technique in a single piece of work, so I thought it might be useful to give you some ideas of combinations you might try to get you started.

If you want to introduce other colours then have a look at the chapter on 'So you Don't Want Blue?' for some ideas on underdyeing, overdyeing and painting your cyanotype. You can also use things like textile crayons and pastels or Markel sticks (oil paint in stick form). Used sensitively these can enhance your images.

Combining negatives and photograms

The first, and simplest combination, is to combine a digital negative with a piece of foliage. I took a digital photograph of the rusty rudder from my husband's boat, cropped the most interesting piece from it and produced a digital negative.

I printed the negative onto a sticky backed, inkjet transparency, removed the paper backing and stuck it onto a piece of prepared cotton. I then loosely pinned a piece of conifer over the negative. The combination was then exposed and processed in the usual way.

A variation of this combination of negative and photogram is the dragonfly picture on the opposite page. I printed the dragonfly as a negative on to a transparency and then cut round it so that the edges of the transparency wouldn't be visible in the cyanotype. The foliage was then pinned round it and the whole thing exposed.

This combination was then expanded out into another piece of work, to produce just over a metre of cyanotyped silk for a shrug (cocoon jacket). I produced a number of the dragonfly cut-out negatives in varying sizes, positioned them on the treated fabric and then arranged and pinned a variety of leaves around them.

Combining negatives and positives

Ideas for work come from all over the place. I was clearing up after a workshop and noticed that some manutex (sodium alginate thickener) had dried in the bottom of a pot and had made some gorgeous patterns like frost. So, I spread some manutex out on to a piece of transparency film and let it dry. I then scanned it at high resolution and cropped out an interesting section. I manipulated it to increase the

contrast and ended up with a positive of the image. I then inverted it to give me this negative on the left.

I divided this into nine panels and printed two sets of these, one set of A3 negatives and one set of A3 positives.

I then printed cyanotype panels on to cotton sateen using negatives and positives alternately. You can see the result at the beginning of the book, opposite the Acknowledgements.

Other textile techniques

For the sake of completeness I just want to refer here to the use of resists that I described in the chapter on preparing the fabric. There I used a silk painting outliner to restrict the area of fabric that was cyanotyped as shown in the Cloud Bird image.

Although this book is primarily about cyanotypes on fabric, it's become quite common for textile artists to incorporate paper into their work so I'm including a few works on paper in the book.

The image below by Penny Kealey was printed on to an old map and I really like the feeling of age and place that she's created. Penny treated the map with cyanotype solution and then used paper cut out crows to make the image.

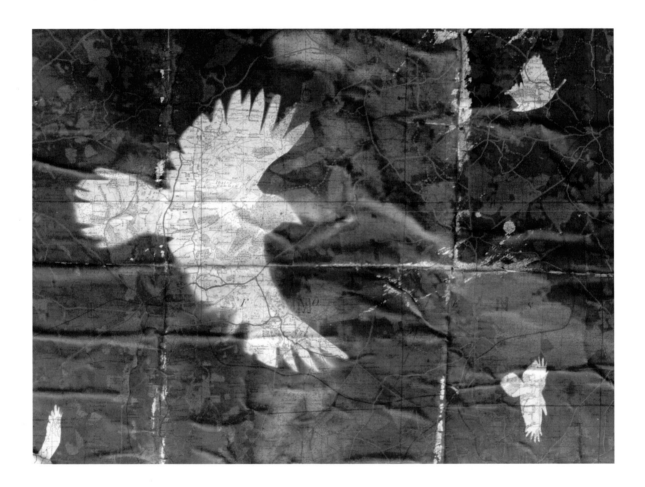

Opposite: This piece called 'Punto in Aria' by Angie Wyman shows beautifully how a piece of cyanotyped fabric can be taken to another level with the addition of other techniques, described below by Angie.

"A hand and machine embroidered Quilt using Cyanotype Silk Noil.

The composition within the quilt is derived from a personal collection of Lace, handed down from family and friends. The imagery depicted conveys the notion of 'Time passed - of another generation', as if layers of sunlight have faded and etched the image of the lace onto the fabric surface. This in turn creates permanence to what is otherwise transient.

Our historical textile language and terminology are explored through traditional quilting and embroidery. Cyanotype silk Noil is used to explore the positive and negative qualities of lace and stitch."

Exposure ...

There's a lovely phrase in 'The Photo Miniature' from 1907 about how light affects the things around us "...working continuous change with its magic touch" [1].

Cyanotypes require ultraviolet light for exposure and this can come from a variety of sources. You can expose a cyanotype simply by laying it in the sun, which is a lovely way to work, and is free, but since I live in the north east of England on the Humber estuary where the air is very rarely still and the weather can change very quickly, I often have to use a UV lamp or sunbed. This does at least have the advantage of being a consistent light that doesn't change direction and there is no problem with wind.

My second hand sunbed can be used pointing at the floor (see the next page) or can be tilted through 90° to point at the wall which will comfortably let me expose large pieces leaning against the wall. Make sure the piece is far enough away from the sunbed so that the edges are exposed too. Actually, as Barbara Hewitt suggests, some very nice effects can be obtained by deliberately underexposing the edges - these then fade away

I also use a small facial solarium about 18" high which works very well for even quite big pieces. You may have access to a UV light box - these are often available at colleges as they are used for a variety of photographic and graphic arts purposes. However, the size of the fabric you can expose is limited to the size of the light box. I'm generally producing a number of small pieces together or a large piece so the sunbed works better for me.

The name ultraviolet means 'beyond violet' (latin 'ultra' meaning beyond) indicating that the wavelength is shorter than the wavelength of the shortest visible light, violet. It is split into UVA (the majority of UV that reaches the earth's surface), UVB and UVC (used in things like pond sterilisation units). Mike Ware recommends UV light sources that operate in the 320-400 nm range and Barbara Hewitt recommends a range of 300-360 nm, that is in the UVA or longwave range. However, neither of the UV light sources I use (the sunbed and the facial solarium) have a stated wavelength, they simply say UVA. The concensus of opinion from various sources is to avoid UVB and UVC light sources for exposing cyanotypes as they are far more hazardous to health. UVA is the safest and most effective range for this purpose.

1 The Photo Miniature – a Magazine of Photographic Information, edited by John A Tennant. Volume VII, September 1907, Number 82, page 433.

Is it cooked?

When the iron salts in the light sensitive solution are exposed to UV light a chemical reaction takes place and they are reduced to their ferrous state. You can judge when the exposure is 'cooked' by the colours changing: exposed areas (that will be blue in the finished image) turn dark blue and then slate grey/charcoal colour. The highlights (unexposed areas that will be white in the image) should still be a yellowy/green and the midtones should be dark blue. This process can take anything from a few minutes in hot, summer sunshine at midday to 30 minutes or more under a sunbed. Sunlight will take longer in winter or if the light is diffuse.

If you are going to be using something like a sunbed on a regular basis you can do a test strip to get an appropriate exposure time. Prepare a piece of fabric and mark it off into, say, 8 strips. Cover the whole piece except for the first strip with something opaque like a sheet of cardboard. Switch on your light source and leave it for 5 minutes. Pull the cardboard back to the next mark and leave for a further five minutes. Continue this reveal and expose sequence until you have exposed the last strip.

At the end, the first strip will have had forty minutes exposure and the last strip will have had five. Process the piece in the usual way. You should have a series of different shades of blue. At some point the colour will stop changing - this marks the time when the exposure was complete. There is no point continuing after this as the colour won't improve and, especially if you are using negatives, the light may start creeping under the design elements, fuzzing the image.

If you have pets make sure they don't come into prolonged contact with UV light - they can get sunburnt or damage their eyes in just the same way as humans do. My cat is mesmerised by the UV lamp and will sit and stare at it given the chance - but then she is a cat of very little brain, lovable but dim!

You might think it reasonable to assume that daylight bulbs would give off UV light but they don't. The daylight part of the name refers to the fact that the colour of the light they emit is adjusted to simulate that of daylight. They don't change the wavelength.

A completed test strip is shown below. The good news is that once you've done a test strip then the timing you use shouldn't change drastically as long as you don't change the distance between your fabric and the light source or the formulation of your solution.

Notes:

➤ You can deliberately under-expose your fabric if you want a paler blue. Look at the test strip to see the range of colour. Remember that unless you use a hydrogen peroxide rinse (see the next chapter on processing) the colour will continue to darken for around 24 hours. You can remove design elements at intervals during the exposure to give a range of tones. This often gives a 3D effect. See the fern photogram on the next page.

➤ If you are using opaque fabric you can turn it over and expose the back with another design if you wish to have a double sided piece.

➤ Silk, for some reason, often doesn't change completely to grey - it keeps a greenish tone. Don't worry about this, you'll still get a good blue.

➤ If you are working on coloured fabric (see the next chapter) it can be difficult to tell when the exposure is complete. The trick here is to place a small piece of white treated fabric next to the coloured one and judge when the exposure is complete by the colour of that one.

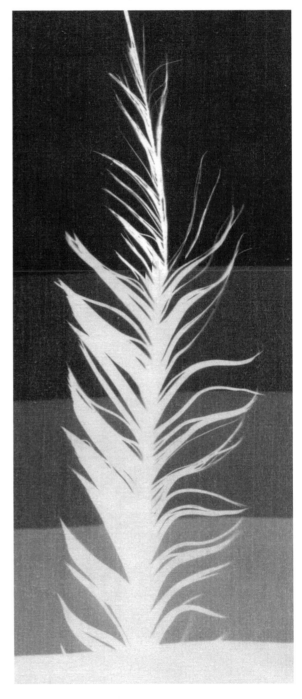

25 mins
or more

20 mins

15 mins

10 mins

5 mins

Whatever your source of UV light you'll get the sharpest images by having the light source at right angles to the fabric. You may have to tilt the board to get the best angle.

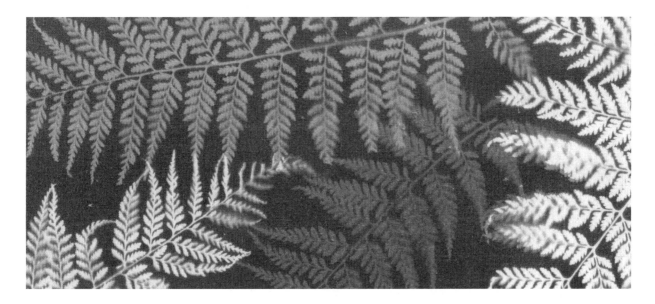

To achieve the effect of the image above, I put the ferns over the treated fabric before I started the exposure. I then removed the darker of the blue ferns (bottom, centre) after about 15 minutes and then the paler of the blue ferns (top, left) after another five minutes. The two white ferns stayed on for the whole 30 minute exposure. If you refer back to the test strip on the previous page you can see how the colour is dependent on the exposure time.

This technique gives a nice appearance of depth.

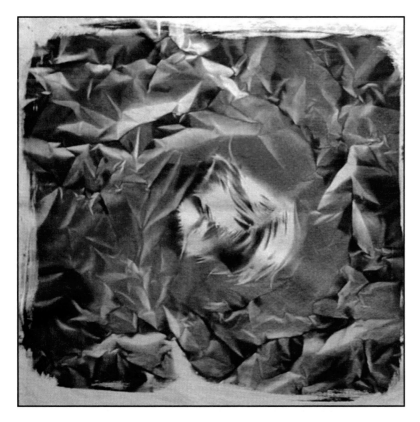

This lovely image by Sue Hadley uses the technique of crumpling the fabric and opening it out gradually during the exposure. Each area exposed to the light source has a different length of exposure and so ends up a different shade of blue.

Sue also created a photogram of a feather in the centre of her fabric by adding the feather during the exposure.

You can also see the result of painting the cyanotype solution on with a brush to get the broken edges.

A beautiful, crystalline image.

Processing ...

This really could not be any easier!

Take the fabric off the support

When the exposure is complete remove the design materials from the fabric in dim light. If you've pinned your design, leave the design elements in place while you take all the pins out. That way the light can't get to the images and start the exposure process in areas where you don't want it. If you are doing a big piece then you could cover the area you have unpinned with light-proof fabric, for the same reason.

I know it's blindingly obvious but do make sure you've taken all the pins out before you start rinsing. At a recent workshop one of my students left three small pins in one of her pieces of work. I did the final rinse of all the group's work, as I usually do, squeezed them to get most of the water out and ended up with two of the pins well embedded in my hand. It was like a paper cut but ten times worse and my language was, um, fruity.

If the processing stage is delayed for any reason put the exposed fabric in a light proof bag or wrap it in something like lightproof fabric, so that it is protected from any more exposure.

Rinse

Plunge the fabric into clean water and swish with enthusiasm. The chemical reaction that has occurred in the areas exposed to UV light results in the production of an iron salt which colours the fabric the distinctive Prussian Blue. This iron salt is insoluble and so does not wash away during rinsing. However, the unexposed chemicals dissolve in the water turning it yellow/green. Change the water for some fresh and repeat the swishing. Repeat this rinsing with clean water until the water stays clear. Use a bowl, sink or bucket that has no cleaning material residue on it that might cause spotting on your cyanotype. A plastic bowl or bucket that is just kept for this purpose is ideal.

Velvet will need a lot of rinsing as it is such a heavy fabric and absorbs a lot of cyanotype solution.

Oxidise and dry

After the print has been well rinsed, hang the cyanotype up to dry or lay it on absorbent paper in subdued light. If any blue appears on the paper re-rinse the fabric thoroughly. The colour will continue to deepen, as the oxidation continues, for 12-24 hours. If you're impatient, and I do tend to be, use a final rinse of a dilute solution of hydrogen peroxide (I buy a 6% solution - 20 vols - of hydrogen peroxide

Can I debunk a myth here - the hydrogen peroxide rinse does not actually intensify the colour of the final cyanotype, it simply speeds up the oxidation process that would happen anyway if the print was left for a day or so.

from my local Chemist where it is sold as a mild disinfectant).
Use a small slosh to half a bucket - proportions are not critical
here! (For those of you who have to measure, I guess it's about a
tablespoon to a gallon/5 litres). This makes the oxidation virtually
instantaneous and you get the rich deep blue straight away. Rinse
briefly afterwards.

After the print is fully oxidised and dried then you can steam iron
the fabric on up to a medium setting and frame, mount or sew it
as you wish. You may notice that the colour fades a little as you
iron it - don't panic, the colour comes back as it cools.

If you live in a hard water area don't leave your cyanotype soaking
in the water as the alkalinity of the water on its own can cause
fading. I inadvertently left a piece in just plain tap water over night
and in the morning I was surprised to see it had turned a bronzy
yellow. At first I thought I must have contaminated the bowl with
some of the washing products I had been testing so I used a clean
bowl and fresh water from the tap and left another piece in to
soak for 24 hours - again all the blue disappeared and left a yellow
print. I tested the water with a PH meter and found it was just over
8 - too alkaline. You can test your water with ph/universal paper or
a ph meter.

For guidance on how to wash and care for your cyanotypes see the
chapter on 'Taking care of your cyanotypes'.

> *PH is the measure of acidity/alkalinity of a liquid on a scale of 1-14. 7 is considered to be neutral, 1 is strongly acidic and 14 is strongly alkaline. A measure of 6 or 7 is therefore good for your final rinse.*

A good idea from Mary Monckton. These prints are on paper and Mary 'stuck' them to the sides of her bath to make it easier to do the final rinses with a water spray.

So you don't want blue ...

While the traditional blue and white image is classical and beautiful there are a number of ways that you can tone or change the colour of your cyanotype. You can use some of the methods of the Alternative Photographers, such as toning in tannin, you can print your cyanotype onto fabric that is already coloured or you can, with care, paint or dye on top of your cyanotype. All these methods can produce beautiful fabrics.

Toning

Photographers working with cyanotypes on paper have developed various techniques for toning their work. Some involve chemicals which aren't really suitable for home use so I've picked out one group of techniques that uses easily obtainable ingredients which are safe to use. Any toning should be done after the print is fully oxidised - after approximately 24 hours or straight after a hydrogen peroxide bath which speeds up the oxidation process (page 66-67).

Toning is usually a 2 stage process: first the cyanotype is converted to a yellow print, then another colour is stained/dyed over the top.

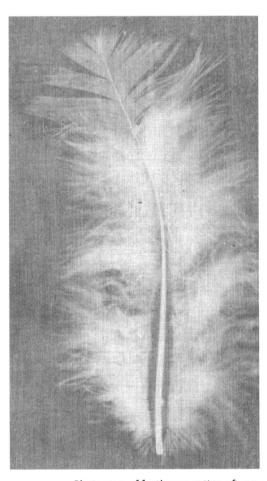

Photogram of feather on cotton after a brief dip in sodium carbonate solution

Convert the image to yellow

To convert the image to a yellow print, make up enough of a solution of sodium carbonate (soda ash or washing soda) to cover the fabric you want to treat and put it into a suitably sized tray or bowl. The solution should be around 20g sodium carbonate to 500ml warm water. A weaker solution will just take longer.

Put your cyanotype into the sodium carbonate bath for a couple of minutes - you can see the blue disappear as you watch so just take it out when it's done. At this stage you have a white image on a yellow to gold background of ferric hydroxide. The exact colour will depend on the intensity of the original blue, so it could range from a pale yellow to a strong golden yellow. Rinse the fabric well and squeeze dry.

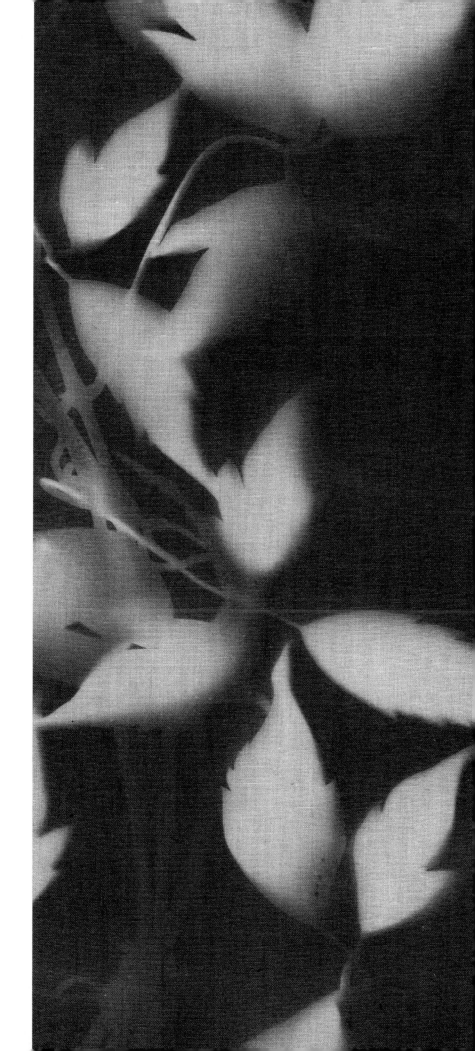

If you take the cyanotype out of the sodium carbonate bath after just a few seconds then you can get a mottled blue/sage green/yellow background, which can be very attractive in its own right - see the feather image on the left.

Judge it by eye and take it out just before you get the desired colour. Rinse in clean water immediately to stop the colour change progressing any further, adding a splash of vinegar to the final rinse if you have hard water.

Stain with tannin to a brown print

For this you need to make up a second bath of either a tannin solution or of strong tea. Try a solution of 20g tannin to 500 ml warm water to start with. Warm water helps the chemicals to dissolve more easily. The tannin is obtainable from home wine making suppliers. Alternatively you can make up some strong tea (10 teabags steeped in a pint of boiling water - we aren't talking herbal or gourmet tea here, just cheap and cheerful, stain-your-mug-brown stuff.)

Put the fabric in the tannin bath and leave it for a few minutes. Timing is not critical here. Take the fabric out and rinse again. Let the print dry and see what you've got.

1

2

3

4

5

Tannin is a very fine powder and flies all over the place, staining a lot of what it touches, so close the windows before you start weighing it out, be careful when you take the lid off and wear a dust mask and protective clothing. The tannin also gets sticky when it's wet so stir briskly and add it in small bits at a time so it doesn't have time to form gloopy lumps (to use the technical term...).

1. Original cyanotype

2. Cyanotype converted to yellow print

3. Yellow print toned with tannin

4. Yellow print toned with tea

5. Cyanotype dipped in tannin, then in sodium carbonate solution, then in tannin again.

Remember that tea/ tannin is a stain, not a dye, so it will probably fade over time and with washing. However, this is easily remedied as you can simply dip it again in the tea/tannin solution.

This strength of tannin gives a reddish brown colour as you can see on the opposite page but if you increase the strength then you can get a lovely chocolate colour. The end result will depend on how dark the cyanotype was in the first place - if you start with a very dark blue print then tone with strong tannin solution the end will be an off-white image on a bitter chocolate background. I've noticed that tea gives a more yellow shade of brown compared to the tannin but it could have been the type of tea I used.

You might also like to try toning in coffee or green tea. There is loads of information on various toning methods in Peter Mrhar's book (see Bibliography).

Just keep in mind that the vast majority of information in books and on web sites is based on paper so may or may not be suitable for use on fabric, especially if you want to be able to wash it.

For the print on the right I toned the original blue print (NOT a yellow print) with very strong coffee and left it for some hours. I really like the almost black colour.

Overdyeing

Natural dyes

After converting the cyanotype to a yellow print you can then use a recipe for a natural dye with the yellow ferric hydroxide acting as a mordant.

I have to admit I know very little about natural dyeing but I have tried dyeing yellow prints with elderberries. This gave a, lovely purply bronze background colour. . Just remember when you are choosing a dye to use that the yellow will still be present in the background colour. Think of the dye as being a glaze over the yellow so a reddish dye will tend to give an orangey brown colour and so on.

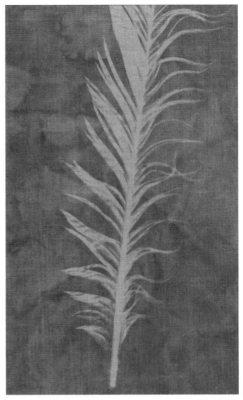

Photogram on cotton, over-dyed with elderberries.

Photogram on silk, overdyed with steam fix silk dyes.

Procion MX and steam fix silk dyes

The options available for over-dyeing cyanotypes depend on the fibre of the fabric used.

Cotton

Cotton is often dyed with Procion fibre reactive dyes which require the use of soda ash as an activator. Cyanotypes won't stand up to alkalies (see How to care for your cyanotypes) so, while you can certainly under-dye with Procions, (see the next page) you can't over-dye with them.

Silk

If you're working on silk you can over-dye with steam fix dyes as they don't require an alkaline environment to work. I found it surprising, but true, that the cyanotype image held up well to being steamed at all!

Underdyeing

There is no reason why you can't produce cyanotypes on coloured fabric that has been commercially dyed or that you've dyed yourself. If the fabric has been commercially dyed then make sure that no surface treatments have been used that might stop the cyanotype solution being absorbed.

If you've dyed a cellulose fibre, like cotton, with procion dyes and soda ash then make doubly sure you have rinsed it thoroughly as any soda ash left in the fabric may cause the cyanotype to be blotchy or spotted. You may want to add a splash of vinegar to the final rinse to make sure.

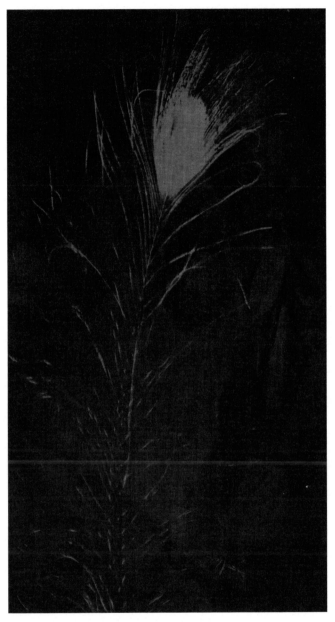

Photogram on lilac Procion dyed cotton, giving a lovely purply blue background

Coloured backgrounds

Another way to influence the colour of your print if it is on a fine or translucent fabric is to put a coloured background behind it. If you are making a garment or wall hanging, you could use a coloured lining fabric. If you are framing a picture then you could use coloured mount board, making sure it **isn't** acid free (see the chapter on taking care of your cyanotypes for an explanation of this).

Photogram on silk dyed in yellows and oranges.
The Prussian blue of the cyanotype giving a green/
brown/rust background with the leaves remaining the
original dyed colours.

I've noticed that silk that has been dyed with steam fix dyes seems to produce a more subtle but very beautiful cyanotype than one on cotton. I don't know why this is, I just relish the result!

Don't confuse silk dyes with silk paints. Paints require heat to set them and they coat the surface of the fibres. Dyes form a chemical bond with the fibres.

So, it seems logical that cyanotype solution will be absorbed into dyed fabric but not into painted fabric.

Opposite: First I rusted a piece of fairly coarse linen. I then applied cyanotype solution and produced a photogram of virginia creeper. You can see that the rust acted as a resist so all the rust marks were retained.

Finally I painted over the whole piece with silk paints to glaze all the fabric not covered by rust with a range of yellows and reds.

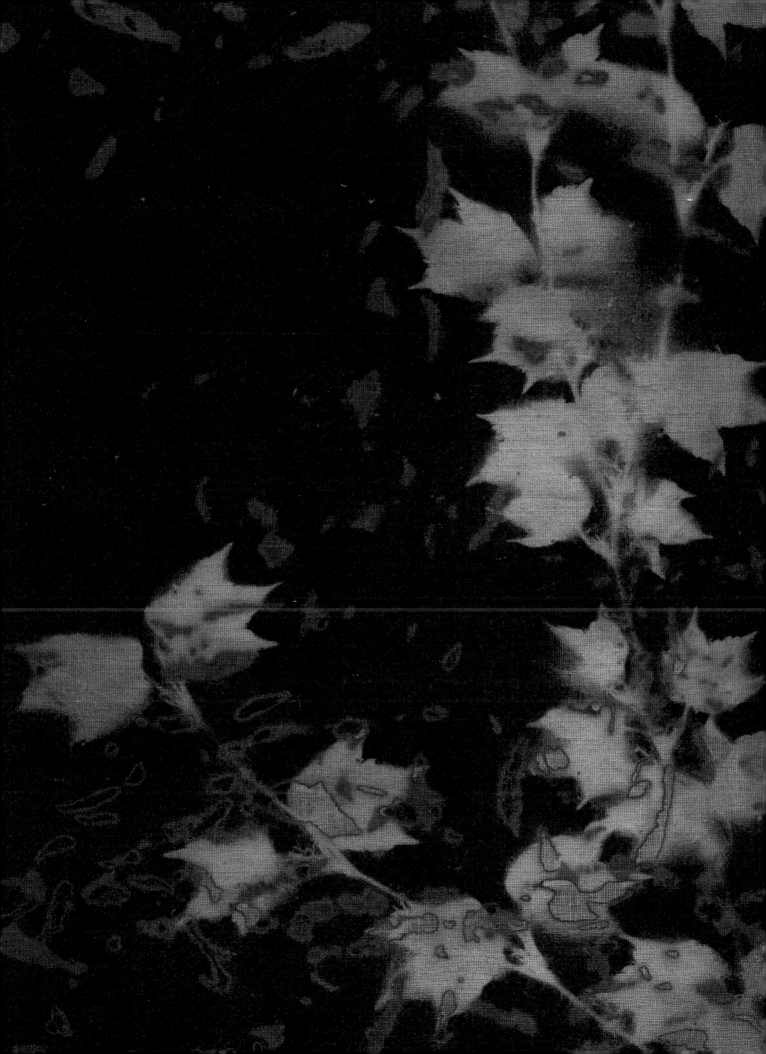

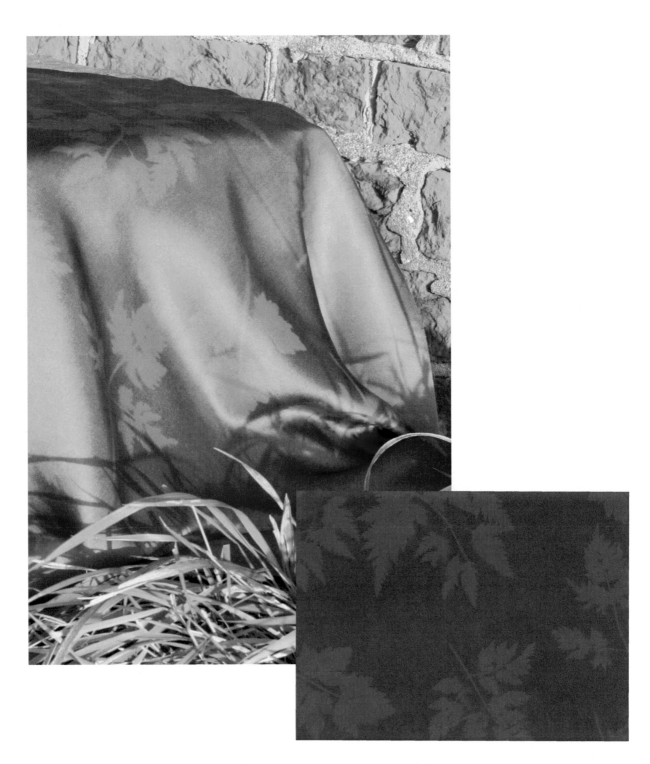

For the piece above I dyed the silk with terracotta coloured steam fix dyes and then steamed the fabric to fix the dye. After it had been well washed and dried I applied cyanotype solution and left it to dry.

Then I scattered sprigs of a weed that grows really well in our garden over the silk and used pins to anchor them down, taking care not to pin through the leaves.

The fabric was then exposed and processed in the usual way to give terracotta coloured leaves on a brown background - the Prussian blue added to the terracotta giving the lovely warm brown.

Overpainting

Since we're working on fabric we have many colouring substances available to us to alter or embellish our cyanotypes; we can use just about any fabric paints, markers and so on. There is a wide range of translucent fabric/silk paints which act like a glaze, allowing the image to show through but giving a colour cast. For instance overpainting a cyanotype with a golden yellow gives a golden yellow image on a dark green background. of course you aren't restricted to one colour when you're overpainting; you could use a general variegated wash or you could colour some areas and not others.l

If you want to paint sharp details on to your cyanotype you can use a thicker, textile paint or a screen printing ink.

If you want a paler colour than your paint, use textile medium/extender to 'dilute' your paint. This will lighten the colour without thinning the the consistency. If you dilute your paint with water then the consistency will be thinner and will be more likely to spread and give a fuzzy outline. You might, of course, want this effect.

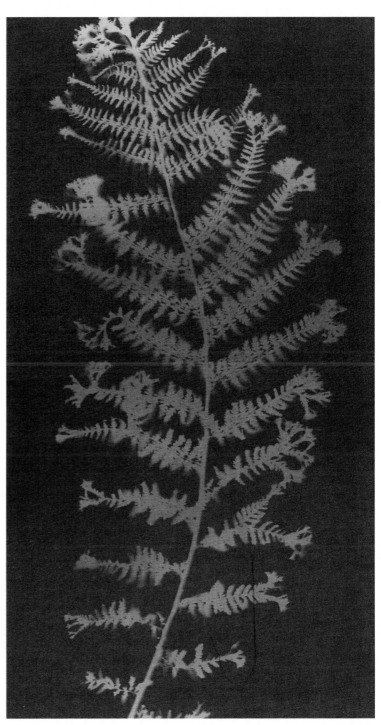

Taking care of your cyanotypes ...

Cyanotypes are permanent and remarkably stable; I was privileged to be able to visit the National Media Museum , formerly the Museum of Film, Photography and Television, in Bradford and saw and handled an album of cyanotypes produced by Anna Atkins in the 1840s. There were also some flower studies by Alexander Hamilton produced in the 1990s. The Atkins' prints were as clear and brilliant as those produced in the 90s and those being produced now.

It's important to remember that cyanotypes need careful handling as they do have some susceptibilities, especially those on fabric as they may need to be washed at some point. They are essentially photographs on fabric not dyed fabric, so you'll need to take the following into account;

Fading in light

Firstly, like most textiles, if a cyanotype is left in strong light it may fade. However, unlike most faded textiles, this is largely reversible. When Prussian blue (ferric ferrocyanide) is exposed to light it can be reduced to Prussian white (ferrous ferrocyanide), which is a colourless substance, causing the image to fade.

To reverse this process leave the cyanotype in a dark place, in the presence of air, until it has regained its original colour or dip it in a mild solution of hydrogen peroxide as described in the chapter on Processing. Both these methods encourage the oxidation of the Prussian white back to Prussian blue.

Now, don't you wish you could do that to hand dyed fabrics to get the colour back!

Fading because of alkaline conditions

The second way to lose the blue of your image is to apply something alkaline. Since we are dealing with fabrics here this usually means being careful what you wash your cyanotypes with and what you overdye with.

For washing, use a small quantity of a mild liquid cleaner which is free of phosphates or bleaching agents like washing soda, chlorine or borax because they will cause the colour to fade or disappear. Try a mild detergent labelled for use on protein fibres like silk or wool such as the original Woolite or Stergene or something like baby shampoo.

Check the label of the product. Unfortunately, in the UK, many washing products don't have a comprehensive list of ingredients so the only safe way is to test a particular product on a piece of cyanotyped fabric; I usually tear the test fabric in two and wash half of it. After washing you can then do a direct 'before and after' comparison to see if there is any fading. If there is no colour change then it should be safe to use in moderation. Whatever product you pick, use the minimum amount possible.

I always keep my cyanotype 'failures' as they come in handy for this sort of testing.

I'd like to pass on a tip from Barbara Hewitt - if you accidentally wash your cyanotype in something that takes the blue out then try toning it with strong tea (see the chapter on 'So you Don't Like Blue?') to give a brown print. As she says, you may even like the end result more than the original!

If you spill something on your cyanotype that takes part of the colour out then you can follow the whole toning process to get rid of the remaining blue and then tone in tea etc.

Be aware that your sink or bowl could have residues of strong cleaners on them that could 'spot' your cyanotype and spoil it.

Also be aware that:

➤ things like deodorant can be alkaline - cyanotyped t-shirts with yellow underarm markings is not a good look ...

➤ if you leave a cyanotype in very hard water overnight, that can be enough to fade it.

Unfortunately, once your cyanotype has lost colour through an alkaline process the original colour can't be reinstated.

Fading from friction

Cyanotypes sit largely on the surface of the fabric so, over a period of time, as the fabric is used and washed then some of the cyanotype is rubbed off. So, as with indigo dyed fabrics, you should avoid surface friction.

Good practice would be to:

➤ hand wash gently rather than machine wash.

➤ iron on the reverse of the fabric

➤ avoid wringing the fabric too hard when you are rinsing.

Fit for purpose

I'm often asked if cyanotype would be suitable for a particular purpose and this is difficult to answer. You need to think about the three considerations above and come to your own conclusion. For instance if I was considering making a cyanotype cushion I would certainly go ahead if it was going to be a decorative cushion that would need minimal cleaning and wouldn't be displayed in direct sun but probably wouldn't if it was going to be cuddled a lot on a settee opposite a south facing window. You get the idea ...

Framing your cyanotypes

Although most cyanotypes on fabric will probably be in the form of clothing, quilts or wallhangings, you may want to frame some of your work. Remember that cyanotypes are sensitive to alkaline conditions so you may not want to use acid free board or paper to mount them or wrap them in as both of these are designed to create an alkaline environment and may damage your print in the long run.

Mike Ware makes the pertinent point that some preparations used to clean glass during the framing process can contain ammonia and should be avoided as the residual alkaline environment could damage your print.

For a description of the chemical background to all this and a much more comprehensive description of the how and why of conservation of cyanotypes see either Mike Ware's excellent book or his web site (see bibliography). Be aware though that the majority of work on conservation of cyanotypes refers to those on paper not on fabric.

About the Artists ...

Cathy Corbishley Michel

Cathy began her interest in Cyanotype (Blueprint) on Fabric after seeing work by the quilter Dorothy Stapleton. After attending a course with me, she extended her technique to include photographic printing with digital negatives. Since 2009 she has been working on a series of large quilted wallhangings based on the Hurley Endurance Photographs, taken in 1914-16 during Sir Ernest Shackleton's near disastrous voyage to the Weddell sea, and his escape from the Antarctic ice after his ship sank.

The Endurance Quilts won Best Large Wallhanging, Best Art Quilt and Runner up Best in Show at the National Quilt Championships at Sandown in 2012. She is currently working on quilt commissions for the South Georgia Museum in the South Atlantic and the Scott Polar Research Institute in Cambridge, and has recently made pieces for the second 'Yorkshire Ones in Antarctica' exhibition at the Hull Maritime Museum from 3rd July - 30th October 2015.

In 2014 she completed a series of quilts based on the Terra Nova expedition of Robert Falcon Scott using photographs by Herbert Ponting, which were exhibited at Sandown 2014 and then travelled to America with the World Quilt Competition as part of the UK entry. The third quilt in the series 'Uncle Bill' featuring Dr Edward Wilson, was exhibited at the National Quilt Championships in Sandown in June 2015

Cathy is based in London and lectures regularly to Quilters, Textile and Embroidery groups as well as Photography associations and the WI. Her talks include both the history of the Cyanotype technique, which dates back to the mid 19th century, and the inspiration behind the Endurance project. All proceeds from her lectures are donated to the South Georgia Environment Fund and/or the Jubilee Sailing Trust. Her work has been featured in a number of books and magazines including Fabrications, Popular Patchwork and Linda Seward's book 'The Ultimate Guide to Art Quilting'.

Website: www.quiltersguild.org.uk/members/page/catherine-corbishley
Email: cathycm33@gmail.com

Barbara Hewitt

Barbara lives in Burlingame, California, where in 1983 she and her husband, John Basye, started Bluprints-Printables, a company offering natural fibre clothing and accessories as well as blueprint-treated T-shirts and fabrics. Her fabric designs have appeared in dozens of juried art-craft shows and in several magazines including 'Fiberarts', 'Piecework' and 'The Herb Companion'.

She has a BA degree in Art from Willamette University, Salem, OR and an All-Level Art Teaching Certificate from the University of Houston, Houston, TX.

Barbara is also the author of 'Blueprints on Fabric - Innovative uses for Cyanotype'.

Penny Kealey

Penny was born on Guernsey in the Channel Islands. She moved to Derbyshire and waited two years for summer - missing the bright flowers, insects and SUN!

She graduated from Newcastle University with a BA Hons Fine Art in 1974 followed by a MFA in 1977. Penny has lectured at home and abroad on fine art/ history of art / printmaking and recently discovered cyanotype at one of my courses. She finds it a process that supports several interests (drawing / photography / found object / printmaking / cultural histories). Her favorite museums include the Petrie, the Pitt Rivers and the British Museum.

As she puts it "can't stop now - washing line always full of 'blue' - and what a magical colour it is - and the perfect return to the SUN!"

Hannah Lamb

Hannah Lamb is a practicing textile artist and lecturer based in West Yorkshire. Her creative practice focuses on walking and making as methods of reconnecting with the world immediately around us. Personal, emotional responses to environment and surface are recorded through stitch, print, photography and construction, piecing together fragments of place and time.

Hannah gained a BA (hons.) Embroidery and MA Textiles from Manchester Metropolitan University. She has lectured in embroidery and design at Bradford School of Arts & Media since 2004. She exhibits nationally and internationally and was recently selected to join the 62 Group of Textile Artists.

Working from her studio in Saltaire, West Yorkshire, she teaches small group workshops in stitch, cyanotype and mixed media textiles. Workshops and talks to guilds and groups can also be arranged.

Website: www.hannahlamb.co.uk
Email: hannahjlamb@hotmail.com

Mary Monckton

Mary comes from a long line of 'hand crafters', making things from a young age, inspired by the hand work of her Canadian Mother and Aunt and the artifacts of her heritage. Like many crafters she skipped from one medium to the next taking bits of each with her on the way.

Mary has lived in many places, including Zambia, the UK, her native Canada, and now lives in retirement with her English husband in New Zealand, so her life is a collage of cultures, seasons and natural heritage.

What intrigues her now is paper as a medium and using found objects from her garden. She finds endless inspiration there from the eucalyptus leaves to the smallest seedpods and heavy limbs of the big macrocarpa or walnut tree. As she says "Meld the natural with time and imagination and art happens". Her main creations from nature include bookbinding, quilting from random pieces of her eco dyeing and telling her life story with the art and craft skills she has acquired over the years. She has done bookbinding with Michael O'Brien in his traditional Victorian Bindery in the Historic Precinct, Oamaru, South Island, New Zealand, for many years as well as several years of bookbinding with Yoka van Dyk, Dutch book artist from Whanganui in the North Island (now deceased). A few years ago she had a week in Whanganui at the Fibre Arts course with Jill K. Berry doing Map Art. Last year she attended the Wanaka Autumn Art School in Central Otago, South Island, New Zealand.

Lynn Taylor, a printmaker from Dunedin (Lighthouse Studio) taught her many forms of printmaking and introduced her to cyanotype which she has been using ever since..

Mitch Phillips

Mitch enjoyed textiles from a very early age. She was taught hand and machine stitching by an old aunt, making dolls' dresses, then her own and finally clothes for her children. However, it was not until much later in life that she decided to study professionally. She was awarded a B.A (Hons.) in Design Crafts in 2001 and in 2005 an M.A with Distinction in Contemporary Applied Arts, specialising in printed/dyed fabrics and machine embroidery.

She has exhibited regionally, nationally and internationally and has been privileged to study with Yoshiko Wada and Hiroshi Murase -renowned Shibori Masters. They chose one of her pieces for an exhibition in Arimatsu, Japan 2005.

Mitch has now retired as a printed textile technician and spends a lot of time with her family and friends. The creative side is still strong and when time allows she visits Art Galleries, Exhibitions and Museums, knitting and tapestry work being her current creative outlets.

In 2013 Mitch was involved with Alice Kettle's project at the Queens House, Maritime Museum, helping to make pieces to go into the 'Flower Helix' which hung down the Tulip Staircase.

In February 2015 she visited Australia and spent a weekend in Sydney with renowned Textile Artist Nancy Tingey participating in a Print workshop held by Liz Jeneid during which she learned new techniques, Collography, Lithography and Etching which may inform any future work.

Email: m_farfalla@hotmail.com

Angie Wyman

Angie is Course Leader for the BA (Hons) Hand Embroidery for Fashion, Interiors, Textile Art at the Royal School of Needlework based at Hampton Court Palace.

As a textiles practitioner, Angie works with hand and machine embroidery to create textile works using found and created imagery and with new and re-purposed materials. Working with cyanotype allows her to map and imprint three dimensional objects onto her own surfaces. Working from collections of family objects and artefacts, she is able to develop compositional effects which are then embellished. The spontaneity of the medium is what excites her. This is balanced with the slower crafting of stitch to enhance and delineate the imagery created through the process.

Angie has an international exhibiting and co-curatorial profile developing thematic exhibitions in response to 'Nets' and 'Networks'; connecting textile practitioners from the UK, Finland and Australia. An artist in residence post in 2012 at the Australian National University, Canberra coincided with a teaching residency at the Geelong TAFTA forum where the 'Nets' project showcased Australian and UK works which were shown together for the first time.

Angie graduated from Loughborough College of Art and Design having specialised in Embroidered Textiles.

Email: angie.wyman@royal-needlework.org.uk
Web site: www.rsndegree.uk

Photogram of an agapanthas on cotton twill
by Barbara Hewitt

Photograph: Barbara Hewitt

Health and Safety

Bob Hewson - CEHP CMIOSH

In this day and age, exposure to chemicals in a workplace is strictly controlled to prevent exposure to harmful substances and to minimise their effects on workers. Whilst there are no similar legal requirements for the use of the same substances at home, some useful lessons can be learned from industry and utilised in order to keep us safe.

Chemicals can enter the body in a surprising number of ways: you can obviously drink or eat them, you can inhale them as either vapours or dusts, you can get them in through cuts and scratches or you can absorb them through your skin or splash them into your eyes. So, with all these dangers, can we safely use the chemicals we need to produce our designs? The answer is, of course, yes, provided we take sensible and suitable precautions.

Chemicals can have different effects on different people and what may cause a reaction for one person may not have the slightest effect on someone else. This is particularly so when it comes to dermatitis.

Dermatitis is an allergic reaction to contact with the skin by a sensitising substance and whilst you may use a chemical in contact with your skin for some time with no ill effects, it may suddenly cause you to suffer an adverse reaction and you may end up with sore and cracked skin.

The best way to avoid this is to protect yourself from exposure to the substance in the first place by wearing suitable protective clothing when handling chemicals of any type, particularly if you have sensitive skin.

General good practice

➤ Keep all chemicals away from places where children and animals could come into contact with them and keep them away from surfaces and areas where you store and prepare food. Don't measure out or use chemicals when there are children or animals around to avoid them getting the various liquids or powders on themselves.

➤ Don't put your liquid working chemicals into bottles that have been used for drinks to avoid the risk of people mistaking them for soft drinks (many serious cases of poisoning have happened like this). Also, when you've made up your solutions don't put them into your normal domestic utensils such as pans, bowls and dishes etc. so as to avoid the risk of them being mistaken for something that is a foodstuff, although it would be difficult to imagine that anyone would drink some of the solutions due to their colour, but there's no accounting for taste (and poor eyesight).

➤ Keep powders in containers with secure lids and label every container with details of exactly what it contains.

➤ Don't rub your eyes with your hands or gloves after handling chemicals; always wash them thoroughly before you do anything else.

➤ Don't contaminate the inside of gloves or other protective clothing with chemicals as this can cause problems with prolonged contact.

➤ Don't pour chemicals into rivers or streams to avoid harming wildlife.

➤ Don't leave contaminated wet clothes in contact with the skin to avoid creating irritating effects.

➤ Don't eat, drink or smoke when handling chemicals so as to avoid getting them in your mouth.

➤ Do cover work surfaces with newspaper or other absorbent material to soak up spillages - it's easy just to gather contaminated paper together and dispose of it.

➤ Do work in a draught free area to avoid powders etc blowing about and contaminating other surfaces.

The Chemicals

The chemicals we use for cyanotyping are fairly commonplace and have no significant adverse effects on us or the environment. However, like most chemicals, they should be used and disposed of with care. We will look at each of them in a little detail over the next few paragraphs.

Hydrogen Peroxide

Hydrogen peroxide is basically a safe chemical in the strength of solution that we use in cyanotyping. It has oxidising and bleaching properties and is often used as a mild disinfectant and antiseptic.

Because it is a clear liquid, care must be taken to ensure that it is not mistaken for drinking water and for this reason alone, do not put it into any container that could be mistaken for a drinking vessel.

Store containers in a dark, well ventilated area and remember that pressure may build up in sealed bottles, so be careful to release the pressure slowly when opening them to avoid splashing the liquid around.

(In very strong solutions don't let it get contaminated with other substances and keep it away from spilling on organic materials such as wood, leather etc as it can react strongly with them.)

Potassium Ferricyanide

Despite its name, Potassium Ferricyanide is not as hazardous as it may sound. The crystals or powder must be kept in a tightly lidded container to stop them breaking down and deteriorating. The containers should be kept in a cool place.

Potassium Ferricyanide should not be mixed with strong acids as this could cause the release of harmful fumes.

Avoid creating dust and don't breathe it in or get it in your eyes.

Ferric Ammonium Citrate

This powder is slightly acidic and can cause skin and eye irritation so the usual precautions apply.

NB If you do spill chemicals on your skin, wash them off immediately with plenty of water and seek medical attention if you accidentally get anything in your mouth or your eyes.

Disposal

Disposal of all three of these chemicals, in the quantities that we use, is fairly straightforward: dilute with plenty of water and flush away, ensuring that plenty of water is flushed down the drains afterwards.

The use of ultraviolet light sources

➤ Never stare at UV light sources as this can damage your eyes. A sensible precaution is to use suitable goggles when working with UV. These can often be obtained from companies that supply them for use with sun beds or for industrial use.

➤ Always make sure that any electrical equipment you use is safe by buying it from a reputable company and having it checked over from time to time by an electrician.

➤ Be careful to use properly earthed electrical equipment near to wet or damp objects and ensure that water does not splash on to hot lamps, as this may cause them to shatter.

And finally...

As you can see, you should have few problems with the chemicals and equipment we use in cyanotyping provided you follow some basic and simple rules. Work carefully and enjoy yourself.

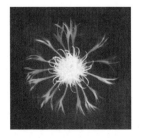

Suppliers ...

Chemicals

Silverprint
12 Valentine Place
London
SE1 8QH
UK
Tel: +44 (0)207 620 0844
E-mail: orders@silverprint.co.uk
Web site: www.silverprint.co.uk

Textile supplies

Art Van Go/Wycombe Arts
The Studios
1 Stevenage Road
Knebworth
Herts
SG3 6AN
UK
Tel: +44 (0)1438 814946
Email: art@artvango.co.uk
Web site: www.wycombe-arts.co.uk

Fibrecrafts
Old Portsmouth Road Peasmarsh Guildford
Surrey
GU3 1LZ
UK
Tel: +44 (0)1483 565800
E-mail: sales@fibrecrafts.com
Web site: www.fibrecrafts.com

Panenka Design Produkte Munchen
85649 Otterloh
Hauptstr. 7a Germany
Tel: +49-(0)89-67 73 26
E-mail: info@panenka.de

Web site: www.patchworkshop.de
(Don't worry about this site being in German as
Guenther Panenka speaks excellent English. You can
find items here that I haven't seen anywhere else.)

Rainbow Silks
Mail order: 6 Wheelers Yard
High Street
Great Missenden
Bucks
HP16 0AL
UK
Tel: +44 (0)1494 862111
E-mail: caroline@rainbowsilks.co.uk
Web site: www.rainbowsilks.co.uk

Sinotex UK Ltd
Unit C, The Courtyard Business Centre
Lonesome Lane
Reigate
Surrey
RH2 7QT
Tel: +44 (0)1737 245450
Web site: www.sinotexuk.com/

Dye specialist

Kemtex Educational Supplies Ltd
Chorley Business & Technology Centre Euxton Lane
Chorley Lancashire
PR7 6TE
Tel: +44 (0)1257 230220
Web site: www.kemtex.co.uk (dyes, auxiliaries and
useful advice)

Fabrics

Doughty's
Fabric Warehouse
100 Barrs Court Road
Hereford
HR1 1EG,
Tel: +44 (0)1432 353 951
Shops:
Patchwork and Quilting
5 Capuchin Yard, Off Church Street, Hereford, HR1 2LR.
Tel: +44 (0)1432 267542
Dress and Craft Fabrics
3 Capuchin Yard, Off Church Street, Hereford, HR1 2LR.
Tel: +44 (0)1432 265561
Needlecraft and Haberdashery
33 Church Street, Hereford, HR1 2LR
Tel: +44 (0)1432 352546

Whaleys (Bradford) Ltd
Harris Court
Great Horton
Bradford
West Yorkshire BD7 4EQ
UK
Tel: +44 (0) 01274 576718
E-mail: info@whaleys-bradford.ltd.uk
Web site: www.whaleys-bradford.ltd.uk
(A huge range of fabrics - will also send out swatches of
fabrics you are interested in.)

Specialist papers and transparency film

On-linepaper.co.uk
Unit 4 Springhill Orchard
Weirwood
Forest Row
East Sussex
RH18 5HT
Tel: +44 (0)1892 771245
E-mail: on-linep@per.co.uk
Web site: webshop@on-linepaper.co.uk
(Extremely comprehensive catalogue including A3
transparencies)

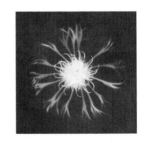

Bibliography ...

Cyanotypes

Blueprints on Fabric - innovative uses for cyanotypes

Barbara Hewitt
Interweave Press - 1995
ISBN - 0-934026-91-2
I understand this is out of print but you may still be able to find a copy.

Cyanotype - the history, science and art of photographic printing in Prussian blue

Mike Ware
National Museum of Photography, Film and Television - 1999
ISBN: 1-900747-07-3
The definitive and comprehensive guide to the chemistry, history and preservation of cyanotypes. The printed book has been out of print for some time but Mike has generously restructured and revised the book and made it freely available as a download from his web site under the title 'Cyanomicon'. I strongly recommend that you visit the rest of his site as well - there are all sorts of useful links and information there.

http://www.mikeware.co.uk/downloads/Cyanomicon.pdf

Blue Prints - the natural world in cyanotype photographs

Zeva Oelbaum
Rizzoli International Publications Inc - 2002
ISBN: 0-8478-2432-2
A collection of cyanotypes with some lovely images - inspirational.

Sun Gardens

Victorian Photograms by Anna Atkins
Larry J Schaaf
Aperture Books - 1985
A fascinating book on the work and times of one of the pioneers of cyanotypes, Anna Atkins.

Blueprint to Cyanotypes

Malin Fabbri and Gary Fabbri
AlternativePhotography.com - 2006
ISBN: 978-1-4116-9838-3

Cyanotype

Historical and Alternative Photography
Peter Mrhar
2013
ISBN: 9781492844594

Alternative Photography

Spirits of Salts

Randall Webb & Martin Reed Argentum - 1999
ISBN: 1-902538-05-6
A lovely book and a good read.

Photo-Imaging

A complete guide to alternative processes

Jill Enfield
Amphoto Books - 2002
ISBN: 0-8174-5399-7

Photo Art

Tony Worobiec & Ray Spence
Collins & Brown - 2003
ISBN: 1-84340-055-3
A lovely and inspirational book on art photography giving many ideas on ways of working and combining techniques. I particularly liked the sections on photomontage, multiple-exposure and photograms.

Digital Negatives:

Making Digital Negative for Contact Printing

Dan Burkholder
Bladed Iris Press - 1999
ISBN 0-9649638-6-8

The Inkjet Negative Companion

Dan Burkholder
Digital book available from Dan's website www.danburkholder.com - 2003

Digital Photography

Step by Step Digital Black and White Photography
John Beardsworth
Ilex - 2004
ISBN 1-904705-52-9

The Digital Printing Handbook
Tim Daly
Argentum - 2002
ISBN 1-902538-17-x

Black & White Digital Photography
Les Meehan
Collins & Brown - 2005
ISBN 1-84340-190-8

Textile books with sections on cyanotyping/ sunprinting

Imagery on Fabric
Jean Ray Laury
C & T Publishing - 1997
ISBN 1-57120-034-7

Transforming Fabric
Carolyn A Dahl
Krause Publications - 2004
ISBN 0-87349-616-7

Dyeing and painting

The Craft of Natural Dyeing
Jenny Dean
Search Press - 2001
ISBN 0-85532-744-8

Silk Painting: The Artist's Guide to Gutta and Wax Resist Techniques
Susan Louise Moyer
Watson Guptill Publications - 1991
ISBN 0-82304-828-4
Useful instructions on using steam fix silk dyes

Tray Dyeing

Exploring Colour, Texture & Special
Effects
Leslie Morgan & Claire Benn
Committed to Cloth - 2006
ISBN 0-9551649-1-5
All you'll need to know about dyeing with Procion dyes.

Shibori

Shibori - the inventive art of Japanese shaped resist dyeing

Yoshiko Iwamoto Wada
Kodansha International Ltd
ISBN: 4 7700 2399 5

Memory on Cloth

Yoshiko Iwamoto Wada
Kodansha International Ltd
ISBN: 4 7700 2777 X

Shibori: Creating Color & Texture on Silk

Karren K Brito Watson-Guptill Publications
ISBN: 0823048152
A lovely book on using acid dyes on silk and shibori techniques.

Useful web sites

I hesitate to recommend particular sites as links change so frequently but if you can't follow one of these links have a look at my web site. There may be an updated link there.

www.alternativephotography.com

www.mikeware.co.uk

www.danburkholder.com

www.unblinkingeye.com

www.stonecreektextiles.co.uk (mine!)

If you are on Facebook there's a great cyanotype Group you might like to have a look at.

Index ...

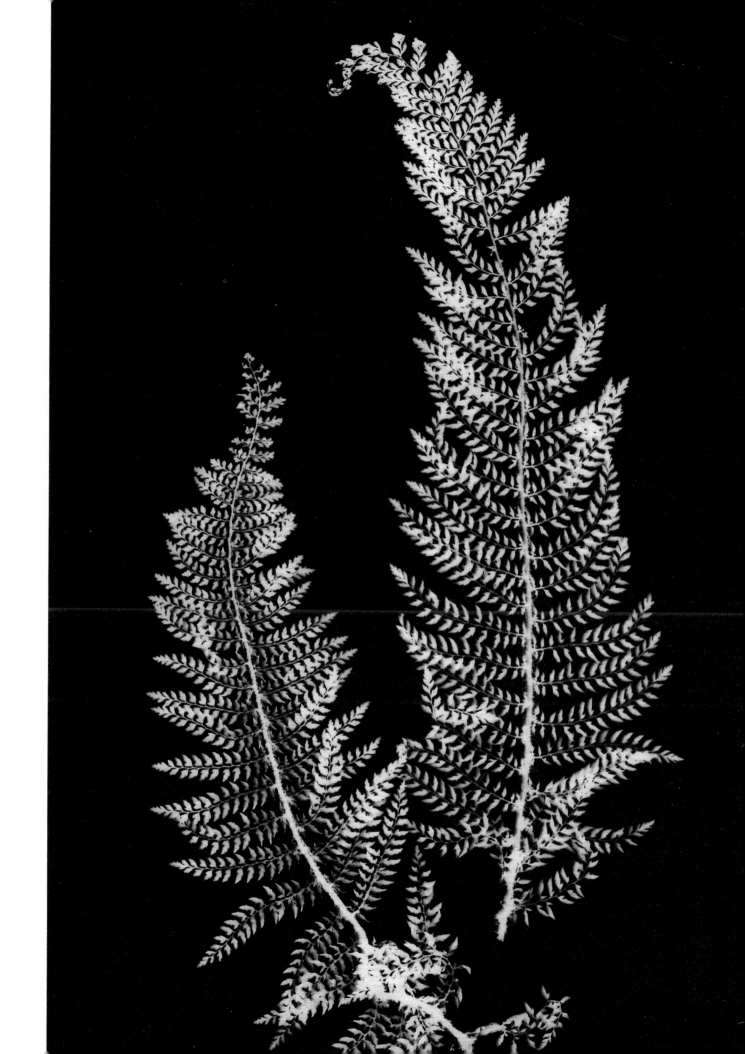

Stone Creek Textiles
by Ruth Brown

Stone Creek House

Sunk Island

Nr Hull

East Yorkshire

HU12 0AP

Tel: +44 (0)1964 630630

E-mail: ruth@stonecreektextiles.co.uk

Web site: www.stonecreektextiles.co.uk

Facebook: www.facebook.com/stonecreektextiles

Made in the USA
Middletown, DE
13 May 2018